ART NOUVEAU SCULPTURE

ALASTAIR DUNCAN

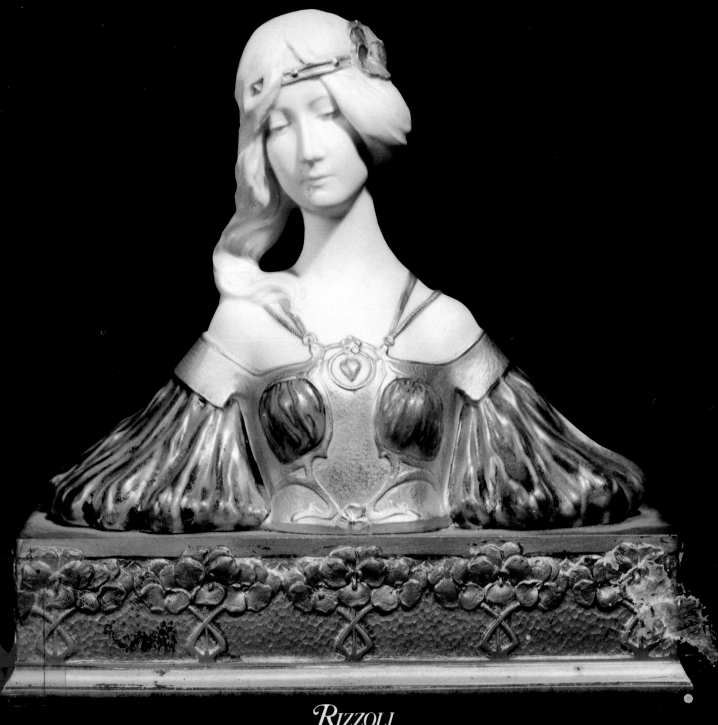

RIZZOLI

ART NOUVEAU
SCULPTURE

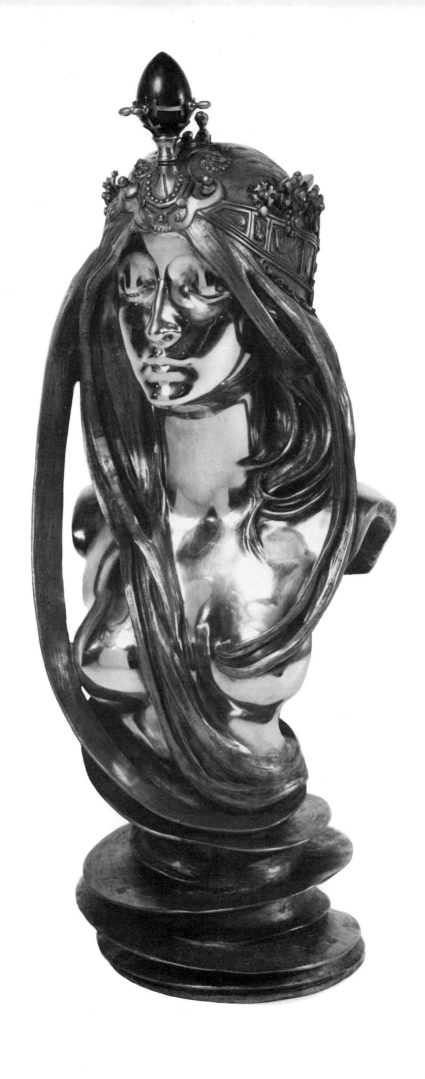

ART
NOUVEAU
SCULPTURE

ALASTAIR DUNCAN

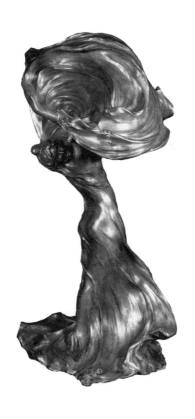

RIZZOLI

DEDICATION

To Ann, Cathy and Penny

ACKNOWLEDGEMENTS

My thanks to the following for their help in the compilation of this book:

In London, to Editions Graphiques Gallery and Victor Arwas for his advice on the text and generous supply of photographs (all other sources are credited in their respective captions); Mollie and Robin Evans in Richmond; Rachel Russel of Christie's; and Philippe Garner of Sotheby's Belgravia.

In the United States, in New York, especially to Lloyd and Barbara Macklowe and Lary Matlick of Macklowe Gallery; Lillian Nassau; Barbara Deisroth and Jean O'Leary of Sotheby Parke Bernet; Leonard Trent; Carol Ferranti; Mr. and Mrs. M. Brigati; Mrs. F. Pratt; and the Photographic Department at the Metropolitan Museum of Art. In Richmond, to Pinkney Near and Emily Robertson at the Virginia Museum of Fine Arts; and to Mr. and Mrs. Sydney Lewis and Frederick Brandt; in Chicago, to Harold Berman and John Stern; in Ohio, to Richard D'Aiuto; in Philadelphia, to Mr. and Mrs. Victor Bacon; in Houston, to Mr. and Mrs. John Mecom, Jnr. and Louis Tenenbaum; in San Francisco, to Stephen and Ellen Gonzales of the Emerald Dragonfly Gallery; and in Indianapolis, to Mr. and Mrs. Wilson Miller.

In Paris, to Félix Marcilhac; Françoise Blondel of the Galerie du Luxembourg; Mr. Benamou of the Galerie Tanagra; and the Librairie Hachette.

Special thanks finally to David Robinson at Christie's New York; Joe Petrellis in Philadelphia; and Rodney Todd-White in London, for their photography. Also to Robert Kashey of Shepherd Gallery for his supply of photographs.

Frontispiece
ALPHONSE MUCHA Bust in silver and gilt-bronze. (Virginia Museum)

Title page
RAOUL LARCHE *Loïe Fuller* Single bulb gilt-bronze table lamp of the American dancer, the bulb concealed in the billowing folds of her robe. (Macklowe Gallery)

First published in the United States of America in 1978 by

Rizzoli INTERNATIONAL PUBLICATIONS, INC.
712 Fifth Avenue, New York 10019

Copyright © 1978 Academy Editions, London

Library of Congress Catalog Card Number 78-58699
ISBN 0-8478-0185-3

Printed and bound in Great Britain

INTRODUCTION

The philosophy that spawned the 'New Art' in the last decade of the nineteenth century had as pronounced an effect on sculpture as it had on the other disciplines within the decorative arts. Tired of and exasperated by the dull pretentions of revivalism that had been the norm throughout most of the century, Art Nouveau sculptors decided, once and for all, to slough off such artistic bankruptcy. No more borrowing from history. The term 'Art Nouveau' became the international battle cry, the *lingua franca* of common dissent; one which, for these modernists, brought a freedom of expression hitherto unknown.

It is important to note, at this stage, that whereas the Art Nouveau movement in general had been conceived in England and subsequently born in Brussels (from where it spread to most of the rest of Europe), its sculptural emphasis was almost entirely French and, more specifically, Parisian. Its history is linked largely, therefore, to the earlier sculpture of that country.

In the nineteenth century the phases in the development of French sculpture had corresponded broadly with the two main divisions in France's political history: the reign of Louis-Philippe from 1830 to 1848 and the Second Empire from 1851 to 1870. It was only with the formation of the Third Republic following the 1870 Commune that sculpture, like painting, could start to rid itself of the debilitating influence of the State.

Prior to 1870 the road to sculptural acclaim had been as clearly defined as it had been narrow. All but a small percentage of French sculptors studied at the Ecole des Beaux-Arts in Paris. There, year after stultifying year, the students competed for the top academic honour, the Prix de Rome, a distinction awarded to those who best interpreted the limited classical idiom of their professors, the latter having themselves passed through the same educational process generations earlier. In addition, for those who defied the system, the tyranny continued over all sculptors, whether Beaux-Arts or not. David d'Angers and François Rude, for example, were forced into exile on the coup d'état of Louis-Napoleon in 1851. The only means of reaching the public was by exhibiting at the yearly Salons, the entries for which were judged by members of the 'Institut', and, naturally

enough, any sculpture that failed to conform to its autocratic standards was rejected. André Précault was totally banned from the Salons from 1834 to 1848, while the works of Barye, Daumier, and Fratin were refused repeatedly. Traditionalism was *de rigueur,* all the more so as the State was for many years almost the only patron in its commissioning of monumental statuary that Baudelaire described so pertinently as 'Heroic didacticism'. As late as 1895 Frédéric Auguste Bartholdi's prize-winning entry in the Salon was his patriotic, yet absurdly titled, *Switzerland Comforting the Anguish of Strasbourg During the Siege of 1870.* Bartholdi's reputation is far more secure when it rests on his *Statue of Liberty* in New York harbour.

Parallel to the Government's patronage of public monuments, however, was the gradual demand, from the 1820s, for private ownership of sculpture as *objets d'art* for home ornamentation. The commercial opportunities afforded by the expanding buying power of the bourgeoisie were first anticipated by Ferdinand Barbedienne (1810-92) who, on opening his foundry in 1838, quickly utilized the invention of his friend and partner, Achille Collas (1795-1859). This, a pantograph, was described in an 1859 obituary

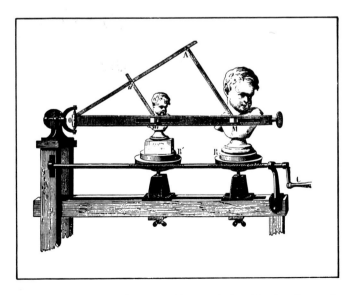

The Collas sculpture-reducing machine, as depicted in the nineteenth century publication *La France Industrielle.*

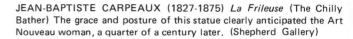

JEAN-BAPTISTE CARPEAUX (1827-1875) *La Frileuse* (The Chilly Bather) The grace and posture of this statue clearly anticipated the Art Nouveau woman, a quarter of a century later. (Shepherd Gallery)

to Collas in the *Gazette des Beaux-Arts* as 'the springboard to the uplifting of the masses'. It operated on a principle of fixed mathematical proportion. A tracing needle moved over the surface of a model (usually plaster or bronze) that was attached by a linkage system to a cutting stylus that reproduced the model on a reduced scale by cutting a soft plaster blank. In a complex model individual parts could be reduced separately and later joined. It allowed for the accurate reduction of marble statues for reproduction in bronze, and harvested both a large number of *bronzes d'édition* and profits for Barbedienne, who drew on all eras of Classical statuary for the subject matter of these limited editions. Favourites were works by Giovanni Bologna and Andrea Riccio. Barbedienne did, though, also cater to the growing demand for Romantic sculpture and in this way provided a forum for its promotion outside of the Salon milieu.

Other foundries and editing houses followed suit in the production of specialised bronzes for the mass market. In Paris, for example, E. Colin, Susse Frères, Louchet, and Thiébaut Frères, were active from the mid-1800s, to be joined during the century's closing years by Hébrard, Houdebine, Valsuani, and Siot-Décauville. These firms either negotiated copyrights with prominent sculptors such as Carrier-Belleuse and Carpeaux to reproduce in metal various of their works or, alternatively, commissioned them to create wax, clay, or plaster maquettes of specific objects for subsequent reduction and conversion into metal.

By the 1890s the revolution sparked by the Communards twenty years earlier had likewise driven the *ancien régime* from the Salons. No longer was sculpture of a pre-ordained style, size, or subject matter. It allied itself now, on the one hand, to the Art Nouveau philosophy of integrated wholes and, on the other, to that of 'l'art dans tout': namely, that all household accoutrements, whatever their function, should be aesthetic. Sculpture was, therefore, 'adapted' into such objects as chimney-mantel garnitures, ashtrays, centrepieces, firedogs, and lamps. These had been considered previously as distinctly beneath the *métier,* this all the more so as these objects were not intended as unique pieces but as the models for serialised editions. Now, however, celebrated sculptors such as Raoul Larche, Théodore Rivière, Pierre Roche, and Maurice Bouval could depend less, if they wished, on the commissions from orders for unique pieces than on the royalties accruing from the mass production of their works in such metals as bronze, ormolu, pewter, or spelter (it is

6

understandable, incidentally, that at a time when Rodin was being hailed as the new Phidias, many of his contemporaries felt the need *not* to compete and so reduced the scale of their sculpture accordingly).

The preferred sculptural materials used at the three Salons that promoted the decorative arts — those of the Société des Artistes Français, the Société des Artistes Décorateurs, and the Salon d'Automne — were marble, stone, terracotta, and bronze. The Manufactory at Sèvres commissioned Agathon Léonard, Léo Laporte-Blairsy, and others to execute figurines in white biscuit porcelain. Mixed-media groups and statuettes were also exhibited by such sculptors as Jean Dampt, Georges Lemaire, and Louis-Ernest Barrias. Ivory came back into vogue following the Belgian colonisation of the Congo by King Leopold, and the Terveuren exhibition of 1897 included a special chryselephantine section that helped to re-establish ivory as a legitimate sculptural medium. The term 'chryselephantine' was first used in Classical Greece to describe statues made of ivory and gold. Its meaning was extended, following the resurgence of ivory into the decorative arts of the 1890s, to encompass any object fashioned in ivory in combination with any other material, especially bronze, marble, or wood.

Sculptors frequently exhibited their work first in plaster and then awaited a Government or private commission to make possible its execution in a durable material. It was often the success of this plaster model which made the work popular. As a general rule, when the model was larger in scale than a statuette, reductions would follow, and with these, the series.

It was bronze that emerged as the unquestioned prince of *fin-de-siècle* materials, due largely to the Collas machine. Founders reproduced bronzes by one of two processes: by lost wax (*cire perdue*) or by sand casting. The former, which had been the major method employed until the 1820s, came back into favour at the turn of the century for serial bronzes as it proved to be less costly. The raw bronze (bronze is an alloy comprising roughly eight to ten parts of copper to one of tin) was closer to the original model than those that were sand cast, and so less 'finishing' was required. Retouchers, engravers (also called chasers) and patinators were well-paid, albeit anonymous, artisans whose services added significantly to the cost per object.

In this respect, readers should bear in mind that serial bronzes, such as the ones illustrated in this

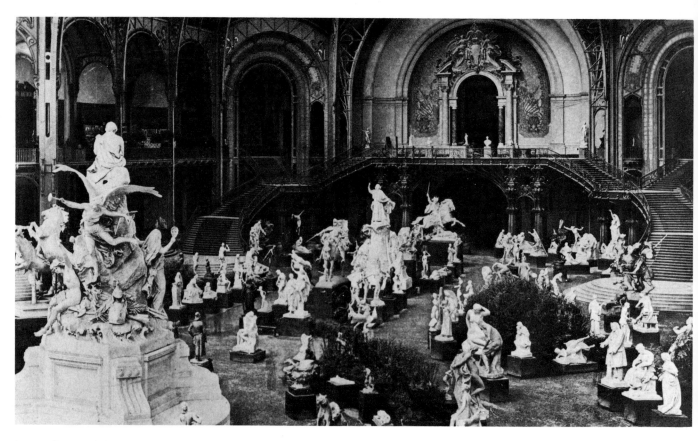

A view of some of the sculpture exhibited in the Grand Palais of Fine Arts at the 1900 Universal Exhibition in Paris.

book, can represent a progeny fundamentally different from their parent, the original sculpture. The serial bronze, despite the sculptor's poinçon or signature on the finished piece, is usually the product of the team work of *other* people. Certainly, in terms of authorship, the concept and execution of the original model are the sculptor's, but a bronze is cast and not sculpted, and the details and dimensions of the original are frequently changed during the finishing operations to which the bronze is subjected. Fissures and holes need to be welded and plugged, and in those instances where, due to the intricacy of the original model, various components have to be cast separately, these must be assembled. Following such preparatory retouching, the piece is ready for the chaser, who attempts to recreate the detail lost during the casting operation with his engraving tool, called a burin. Finally, the bronze is patinated.

The term 'patina' refers in this instance to the artificial alteration of the natural surface colour of a metal. A solution of mineral salts and acids is painted on to the piece of sculpture and heat is applied with a torch to accelerate the chemical reaction. Most Art Nouveau bronze and spelter objects were finished in this manner, the applied colours ranging from *vert-de-gris* to a deep chocolate. Non-metal materials, such as plaster and terracotta, were also frequently finished in a brown or polychrome wash. This gave them an antique look and made them appear, to the uninitiated, to be of metal and therefore of greater intrinsic value.

The final appearance of a serial bronze depends to a large degree on the skill and sensitivity of the team of craftsmen. Whereas the sculptor can oversee one or all of these finishing operations, he may not oversee any of them at all. The original nuances and symbolism of his work can be diminished or lost.

Art Nouveau bronzes were then, as now, not cheap, and an alternative method of producing serial sculpture was the electro-typing process patented by Christofle. This allowed for the use of cheaper base metals, such as zinc, which were electroplated with a more expensive metal. At the turn of the century silver was the most commonly used 'noble' metal with which to plate alloys.

For their inspiration Art Nouveau sculptors drew on the same range of themes that were applied to other aspects of interior design. The botanical and entomological motifs on Gallé's cameo lampshades and on Lalique's jewellery were also to be found on sculptural objects. The insect demi-monde of the praying mantis, the cicada, and the stag beetle swarmed and crawled across inkwells, centrepieces, and vases that had cunningly been disguised as convolvuli and waterlilies. Whiplash and scroll-work designs — taken to their apogee in the cast and

8

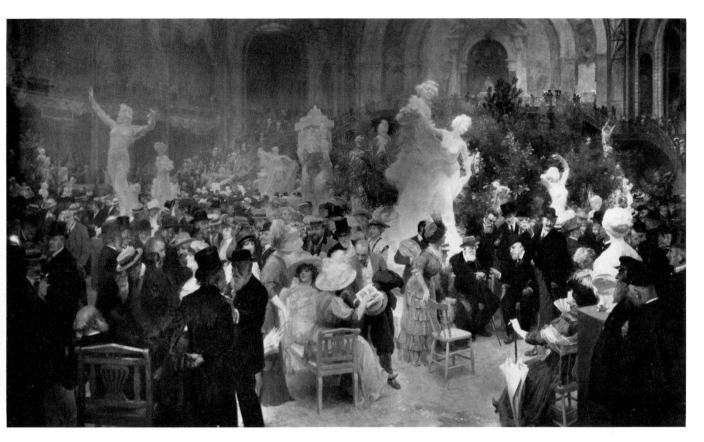

JULES GRUN *Un Vendredi au Salon* (Friday at the Salon) c. 1911.
The Salon was an important event in the annual Parisian social calendar;
one in which it was vital for aspiring sculptors to participate.

wrought openwork balustrades of Victor Horta and in the writing extravagances of Hector Guimard's Metro entrances — likewise were given expression in sculpture. All of the period's most recognisable themes — and clichés — were, in fact, used, though none more so than 'Woman'. Her domination of the decorative arts of the 1900s, and of sculpture in particular, warrants special mention.

Representative of everything for which *La Belle Époque* and *Les Années Insouciantes* stood (so erroneously), women appeared on almost everything in low, high or full relief. Freed from the real life metal and whalebone harnesses into which fashion had locked them, and freed also from their equally stifling respectability so aptly portrayed in the novels of Stendhal, Balzac, and Flaubert, women threw caution, clothes, and corsets to the winds. This, at least, was how Art Nouveau designers depicted them; a depiction that the critics at the Salons tended to endorse in their reviews. Interpreted as nymphs, naiads, or undines, who were variously melancholic, ethereal, or somnambulistic, the maidens that adorned sculpture in the 1900s had their antecedence in the Symbolist movement that had pervaded the worlds of both literature and painting in the 1880s.

The Symbolists were inspired initially by the English Aesthetic Movement and by the Pre-Raphaelites. Their distaste for realism could be found in the Baudelairean ideal of 'Sois belle et sois triste' (Be beautiful and sad) and in Rossetti's *Beatrice*. No longer were Courbet's models, who had never been troubled by so much as the shadow of a thought, of sufficient intellectual inspiration. Now the women painted by Gustave Moreau, Pierre Puvis de Chavannes, Fernand Khnopff, and Odilon Redon incorporated a blend of the satanic, erotic, spiritualistic, and the funereal. Philippe Julian, in his *Dreamers of Decadence,* described the formula for the new 'Belle Dame sans Merci' as follows:

Princess or artists's model, sphinx or succubus, Sappho or Ganymede, the *fin-de-siècle* insisted that the face should be moulded by the soul, and this was the mask which obtained the greatest success. In order to be desirable in a milieu which had turned its back on materialism, woman had to become a lily if she did not want to be condemned as vulgar by the Aesthetes. If woman could not be childlike and innocent, she was expected to inspire evil desires.

And this she did. With her enigmatic expression and eyes closed to conceal an inner world of reveries, the Symbolist woman conjured up images of death-ridden chimeras, sorcery, and the current cult for hallucinatory drug-taking.

The Art Nouveau woman, in turn, represented an

9

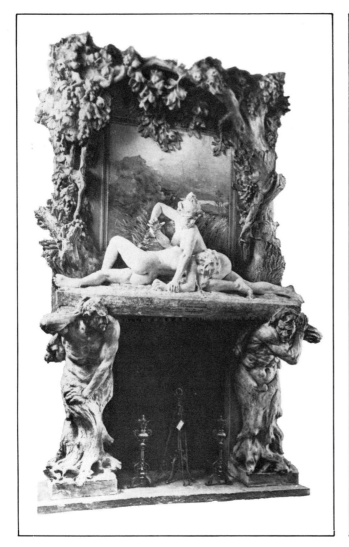

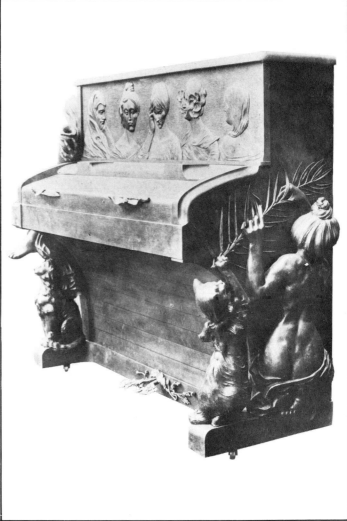

FELIX CHARPENTIER Chimney piece shown at the 1900 Universal Exhibition.

RUPERT CARABIN Piano in sculpted walnut and wrought iron, commissioned by the comedian Coquelin-Cadet of the Comédie Française in 1901. The bronze pedals are in the form of asters. (Galerie du Luxembourg)

offshoot from this theme, although a rather effete one. Gone was the *femme fatale;* in her place a tousled enchantress. Nowhere in the posters of Jules Chéret, Manuel Orazi, Alphonse Mucha, or Privat Livemont, the canvases of Gustav Klimt, or the gouache drawings of Georges de Feure, can one detect such innate evil. Three-dimensionally, likewise, the expressions on the faces of the nudes who reclined or gambolled across bronzes and marbles were largely softened, their decadence exorcised. Woman's new role was allegorical. She was still symbolic, but now personified such ideals as Justice, Faith, Truth, and Progress — in the last-mentioned no more so than when, brandishing aloft a torch, she became the Fairy Electricity. As this she symbolised the invention of the incandescent filament bulb and, thereby, the triumph of Science over Mechanics, of the new century over the old.

Nobody personified the electric light more in sculpture than the American dancer, Loïe Fuller. Arriving in Paris in 1892, she established herself at the Folies-Bergère where the uniqueness of her various illuminated dances led to immediate and spectacular success. Isadora Duncan, initially a protégée of Miss Fuller, described Loïe Fuller's impact on the audience in her autobiography, *My Life:*

Before our very eyes she turned to many-colored shining orchids, to a wavering flowing sea-flower and at length to a spiral-like lily, all magic of Merlin, the sorcery of light, color, flowing form. What an extraordinary genius . . . she was one of the first original inspirations of light and changing color — she became light.

The electric light was still, of course, a curiosity and this made Loïe the inspiration for numerous sculptors who endeavoured to convey the magic of her performances in metal or ceramics. Several of these are illustrated in the following pages.

The sculpture of Rupert Carabin is not as widely known as that of many of his contemporaries since the majority of his commissions were for unique

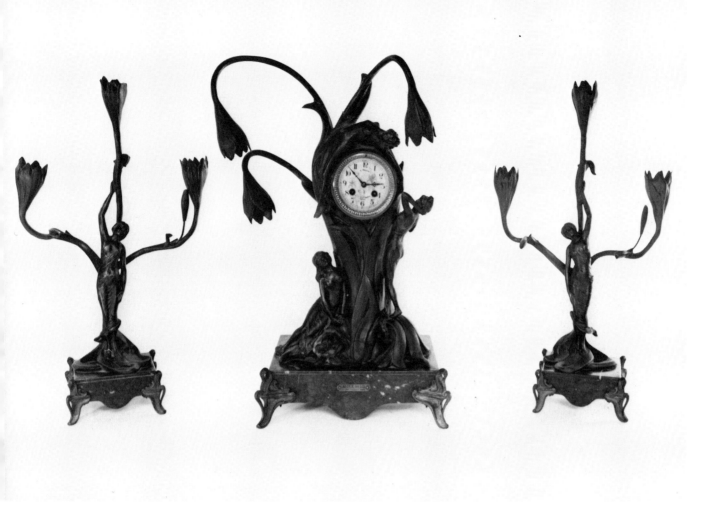

CHARLES JONCHERY *Agonie des lis* Three-piece garniture mantel set in patinated metal on red veined marble bases, comprising clock and two candelabra. (Author's collection)

pieces. They were executed for a select group of clients, foremost among whom was Albert Kahn, founder of the famous gardens of the Bois de Boulogne. Whereas Carabin did produce several series of small bronzes for the general market, these constituted only a small percentage of his output and effort.

Carabin was born in Saverne, east of Nancy in Alsace. The family moved to Paris, where at the age of eighteen he became a sculptor in wood at a furniture makers in the faubourg Saint-Antoine. Later he opened his own studio in the rue Richomme. In 1884 he participated in the first Salon of the Société des Artistes Indépendants, showing a wax figurine alongside the works of Seurat, Signac, and Dubois-Pillet. In 1890 came Carabin's first of several clashes with the authorities: the Jury at the Salon refused to allow him to exhibit a bookcase which he had been commissioned to make by a Mr. Montandon. The bookcase, in carved walnut and wrought iron, incorporated ace masks of the base passions that work against

intelligence: Vanity, Greed, Intemperance, Folly, and Hypocrisy. On the top shelf were three allegorical nude women representing the higher regions of the mind. It seems astonishing, in retrospect, that the Jury should have found either this theme, or its implementation, to be offensive.

In 1913 another of Carabin's works was refused by the Jury, and in 1919 his entry at the Salon of the Société Nationale des Beaux-Arts provoked a major scandal. He exhibited a wooden chest which bore the inscription 'Regard chaste, laisse-moi clos' (Look pure, leave me closed). Inside this Pandora's Box was placed a group of two naked women indulging themselves enthusiastically in lesbian intimacy. Paris was outraged. In 1920, Carabin, perhaps with a sense of self-exile, left Paris to take up the post of Director of the School of Decorative Arts in Strasbourg.

Carabin's preferred sculptural material was wood: pear, oak and especially walnut. He also produced a substantial amount of sculpture in plaster, bronze, earthenware, and pewter. Women were his dominant

theme. With muscular and rounded bodies, serious faces, and hair tied in a chignon, they acted as the caryatids who supported table tops, arm chairs, writing cabinets, and comfit-dishes. The habitual companions of these maidens were cats, bats, frogs, and octopuses. They, too, had their function, acting as arm-rests, handles, and lock plates.

One of the most celebrated of the Parisian Art Nouveau sculptors was Raoul Larche. The son of a craftsman, Larche had been a student of Alexandre Falguière and Eugène Delaplanche at the School of Fine Arts in Paris before making his debut, in 1881, through the Société des Artistes Français.

An undated catalogue in the Musée des Arts Décoratifs at the Louvre from a posthumous exhibition of Larche's works is the major key to the extent of his life's work; a life that was tragically cut short in 1912 when, on running forward to prevent his friend, the banker Max, from being hit by a car, Larche was himself run down. The exhibition displayed hundreds of Larche's paintings and sculpture, the latter as varied in its subject matter as it was diverse in its materials. Busts of mythological deites, groups of peasant girls, figurines of sword-bearing youths and of naiads clasping conch and triton shells, were executed in a bewildering array of stone, white biscuit porcelain, pewter, bronze, and terracotta. To these were added a range of heavily-accented Art Nouveau bronze objects: busts, table lamps, inkwells, and *cache-pots.*

Another prominent sculptor at the turn of the century was Louis Chalon. Initially an artist, he became an accomplished illustrator, gem-setter, and couturier of royal capes. His entry into the realm of sculpture in 1898 was fortuitous: on being asked to do a series of *trompe-l'oeil* illustrations intended to give the impression of white and blue porcelain, he decided, after several unsatisfactory attempts, to model them first in painted wax. The resulting effect was so charming that further models for other objects followed, and these, in turn, became the maquettes for an extensive range of bronzes cast by the founder Louchet. Chalon had a prediliction for the woman-flower hybrid. Nubile maidens clamber or frolic on vases, garniture mantel sets, sweetmeat boxes, and centrepieces. His design for *Vase of the Hesperides* for the 1900 Universal Exhibition was executed for him by the ceramist Emile Muller. The vase stood seven feet high and depicted the three daughters of Atlas supporting the sea monsters who guarded the garden of the Hesperides.

JEAN-LEON GEROME *Corinthe* Tinted marble statue with gilt-bronze, opals and turquoise. The inscription on the capital column reads *Non licet omnibus, adire Corinthum.* (Shepherd Gallery)

Born in Toulouse, Léo Laporte-Blairsy received his art training, like so many of his contemporaries, from the grandmaster Falguière. He made his debut at the Salon of the Société des Artistes Français in 1887. Initially a sculptor and engraver of rather large monuments and busts, Laporte-Blairsy decided in the late 1890s that he would reduce the scale of his work to meet the increasing demand for household *objets d'art.* His main area of concentration was on sculptural lamps. The themes for these, described in 1903 by the critic de Felice as 'luminous fantasies'; represented a strange mixture of the anecdotal, the eclectic, and Art Nouveau. Some, such as his table lamp *La Fillette au ballon,* which depicts a young girl holding up a balloon that she has just bought from the Magasins du Louvre, tell a story. Others, fashioned either as Breton women or Greek dancers, are historically inspired. Others again, such as his umbel and peacock table lamps, are pure 1900.

Maurice Bouval exhibited his work through the Société des Artistes Français and La Maison Goldscheider. His bronzes combined, on the one hand, sensuous nymphs, water lilies, lotuses, and poppies with, on the other, a sometimes strong suggestion of symbolism and the supernatural. There is, in the heavily-lidded eyes of his *Ophelia* bust, the mystique of his *Le Secret* statuette (no doubt inspired by the one by Pierre Fix-Masseau on the same theme several years earlier), and the trance-like state of the maidens in his *Dream* and *Obsession* candelabra, something of the phantasmagoria of Poe and the 1890s Parisian rage for the *heure de la verte* (absinthe-drinking time).

Joseph Chéret was a sculptor who, following tutelage under Vallois and Carrier-Belleuse (Chéret subsequently married the latter's daughter), made his Salon debut in 1863. In 1887 he succeeded to the directorship of the modelling studio at the Manufactory of Sèvres. Chéret died in 1894, before Art Nouveau had become firmly established, but his style anticipated the movement's high-point which came fully ten years after his death.

Chéret's designs for bronzes were executed by the Parisian founder Soleau and would normally, on his death, have ceased to be reproduced. His style, though for the most part Second Empire, was on occasions transitional: part Classical and part Art Nouveau. Gilt-bronze putti either romp amongst roses and water lilies (the corolla of which sometimes house electric bulbs) or lavish attention on some of the earliest of *fin-de-siècle* maidens. Soleau was quick to determine, after 1894, that Chéret's

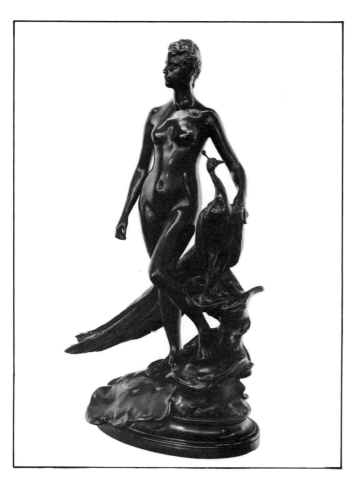

ALEXANDRE FALGUIERE *Juno and the Peacock* Bronze on oval red marble base. Founder's mark of Thiébaut Frères.

LOUIS-ERNEST BARRIAS *Jeune fille de Bou-Saada* Bronze with gold, black and honey-coloured patination. Foundry mark of Susse Frères (Shepherd Gallery)

theme was increasingly in vogue, and he therefore had several of the original range of bronzes re-cast from Chéret's models, still in his studio. Later editions occurred in 1900 and 1904.

Charles Korschann was born in Brno, Moravia. Following his graduation from both the Viennese and Berlin Schools of Fine Arts, Korschann led a maverick life, with sojourns in Paris (1894 to 1906), Berlin and Frankfurt (1906 to 1914), Cracow (1914 to 1919), and thereafter, again in Brno. A sculptor and medallist, it was during his stay in Paris that he designed a series of Art Nouveau small objects, such as clocks, inkwells, and portrait busts (in 1904, for example, he was commissioned by the Moravian Museum in Brno to do a bust of Alphonse Mucha). These were exhibited through the annual Salons from 1894 to 1905.

A generation older than most of those who applied their talents to the Art Nouveau movement, Jean-Auguste Dampt had already, by 1876, attended both the School of Fine Arts in Dijon and Paris, and made his debut at the Salons. Primarily a sculptor, he switched readily from marble to stone, to wood, to ivory, to emerge as one of the period's most versatile mixed-media exponents. He exhibited such objects as furniture, sculpture, and light fixtures through the

Société Nationale des Beaux-Arts and the exhibitions of the 'L'Art Dans Tout' set of artists. Dampt is remembered for his superlative *La Fée Mélusine et le chevalier Raymondin* group in 1894 of a knight in steel armour kissing a jewel-encrusted ivory maiden, and for his wood and ivory *Paix du foyer* statuette four years later.

Agathon Léonard (this was a pseudonym: his real name was Léonard-Agathon van Weydeveld) was born of Belgian parents in Lille, where he attended the Academy of Fine Arts. Settling in Paris, he became a member of the Société des Artistes Français in 1887 and then, in 1897, also of the Société Nationale des Beaux-Arts. He designed and executed portrait busts, groups, and statuettes in rose quartz, green Egyptian marble, *flambé* earthenware, bronze, ivory, and plaster. In 1902 he exhibited two particularly fine busts in rose quartz, white marble, and gilt-bronze at the Salon of the Société Nationale des Beaux-Arts. These were titled *Melancolie* and *Meditation*. Léonard is now known almost exclusively for his *Jeu de l'écharpe* (scarf game) series of female figurines. These he first displayed in 1897 as a 'project for the decoration of the foyer of a dance hall'. Later the Manufactory at Sèvres commissioned Léonard to model them in white biscuit porcelain for their

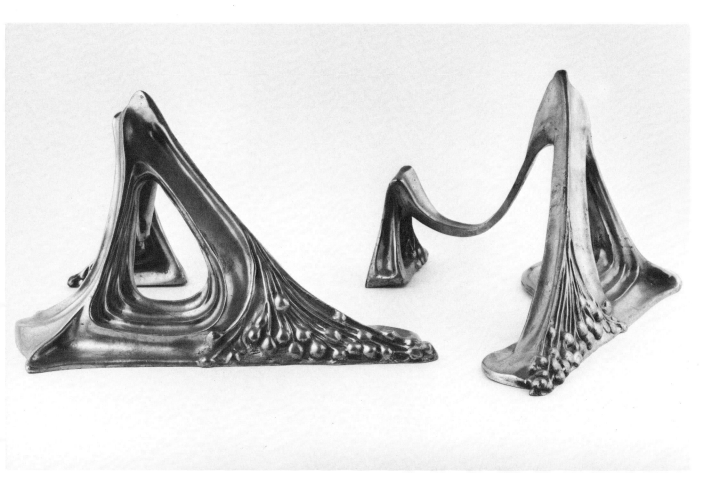

PAUL FOLLOT A pair of gilt-bronze andirons. (Sydney and Frances Lewis)

pavilion at the 1900 Universal Exhibition. Pieces could be bought either as the complete set or individually, and so successful was the project that the founders, Susse Frères, subsequently bought the right to have the originals cast in bronze.

On leafing through the catalogues of the annual Salons in Paris at the turn of the century, one sees just how many sculptors there were, and why it is that today there is still a substantial supply of objects to be found from that epoch in flea markets, antique shops, and auction houses. As one scans the alphabetical lists of participants and their exhibits, one finds statuettes by Lucien Alliot, Max Blondat, and Julien Caussé; groups by Félix and Alexandre Charpentier; candlesticks and plaques by Georges Flamand, Charles Jonchery, and Auguste Ledru; sculptural lamps by five of the Moreau family; and portrait busts by Théodore Rivière, Pierre Roche, Villé Vallgren, and Emmanuel Villanis. And so on. The lists are extensive.

Outside Paris, Art Nouveau sculpture was less frequently undertaken. In Austria, Gustav Gurschner displayed his work through the Viennese Secession group from 1898, later participating in numerous exhibitions in Munich, Paris, and Monte Carlo. His reputation grew accordingly. In the early part of his career he devoted himself to monumental groups and portrait busts, but then, like Laporte-Blairsy, he turned his hand to smaller household objects such as door-knockers, lady's hand mirrors, pentrays, and lamps. Gurschner's metalwork shows great refinement. Even his use of bare-breasted young women — potentially such a hackneyed theme — as the central figures in many of his objects, largely survives any stricture in that they have a quiet dignity and poetic charm that never stoops to vulgarisation. A favourite Gurschner theme was the use of sea-shells — for example, the chambered Nautilus and the Turbo Marmoratus — to house the electric bulbs in his sculptural lamps. The shells' innate translucency produced a richly luminescent effect when backlit.

In Germany, the firm of J.P. Kayser-Sohn in Cologne manufactured a range of pewter objects. Experimentation in metallurgy resulted in the firm's adoption of a new admixture of copper and antimony. This gave the pewter alloy a silvery brightness and added extra durability. Kayser-Sohn participated in the German Jugendstil movement, producing domestic ware such as *jardinières* and candelabra.

Southeast of Stuttgart, in the town of Geislingen, is situated the firm of Wurttembergische Metallwarenfabrik (W.M.F.). At the turn of the century, when the

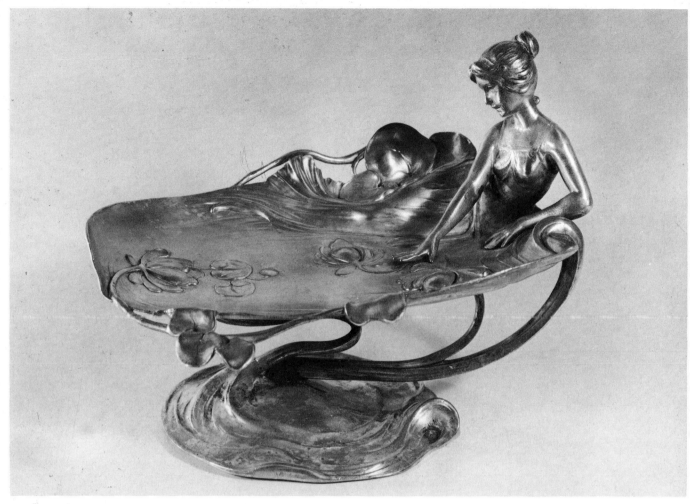

WURTTEMBERGISCHE METALLWARENFABRIK Electroplated metal visiting-card tray. (Macklowe Gallery)

firm's number of employees had swollen to 3,000, a wide range of metalware in silver, nickel, pewter, and copper was manufactured and then marketed through sales outlets in cities such as Cologne, Vienna, Berlin, and Warsaw. Traditionally-inspired styles — for example, Neo-Renaissance and Rococo — which until that time had constituted the cornerstone of W.M.F.'s output, were largely shelved so that the firm could concetrate on Jugendstil, then rampantly *à la mode.* Silvered metal and pewter objects, such as centrepieces, tazzas, and visiting card trays, were produced in the prevailing Art Nouveau idiom. W.M.F. candelabra, with their draped women supporting twisted stems culminating in scrolled motif candle-nozzles, seemed plagiarised variations on their French *femme-fleur* counterparts; the aesthetic price of commercialisation for the mass-market.

In Brussels, crucible of 1900 avant-gardism, Philippe Wolfers was apprenticed to his father's studio in 1876 before studying under Isidore de Rudder as a sculptor. It was only after the Terveuren exhibition in 1897, at which he showed such works as his *Fée au paon* and *Caresse de cygne,* that Wolfers began to concentrate on jewellery. His *Fée au paon* statue is one of the period's masterpieces. It consists of a life-size naked

marble woman holding a bronze peacock. Electric bulbs are positioned in the peacock's tail, the light rays being transmitted through the *plique-à-jour* enamel 'eyes' set in the bronze. Wolfers displayed a similar group in ivory and bronze at the 1901 Salon of the Société Nationale des Beaux-Arts in Paris.

Also in Brussels, the sculptor and medallist Egide Rombeau worked with the silversmith Franz Hoosemans to produce a series of highly decorative candelabra and small table lamps. Hoosemans fashioned the silver tendrils and stems that enveloped Rombeau's sculpted and polished ivory maidens to culminate in flower-form candle-nozzles or bulb-holders.

Art Nouveau sculpture carried the seeds of its downfall within it. Woman was exploited *ad nauseam,* and the public's appetite was soon satiated. Today's frenetic revival of interest in the auction room and amongst antique dealers, however, has assured that her reincarnation is to be more permanent.

Opposite
CHARLES KORSCHANN Gilt silvered and patinated bronze vase.

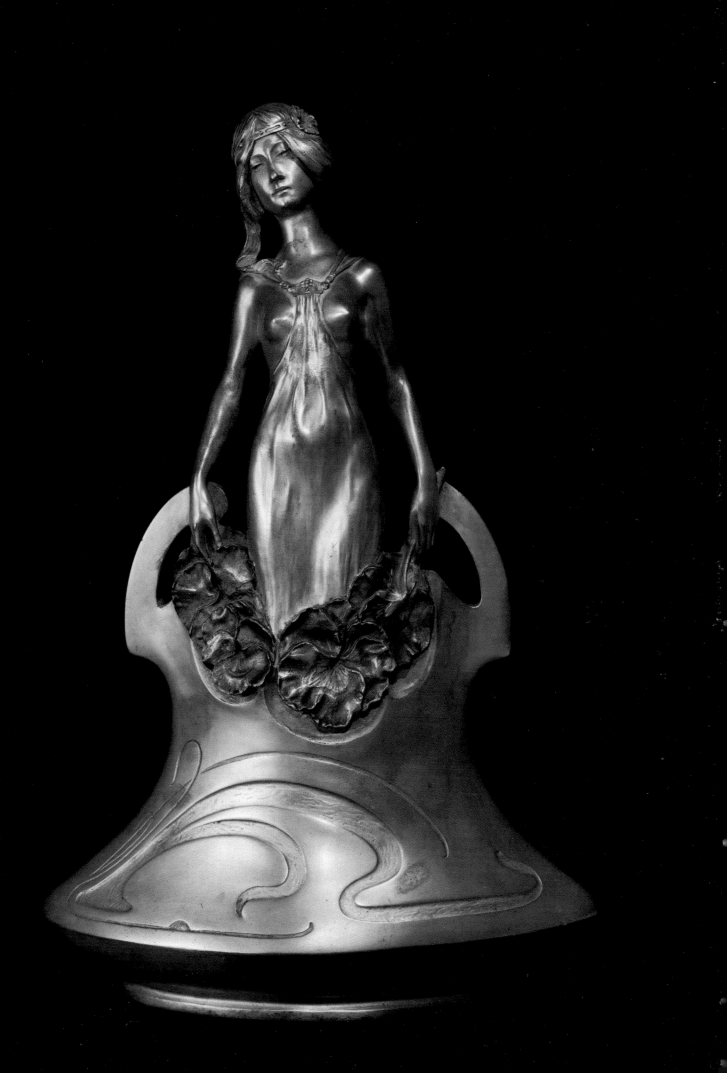

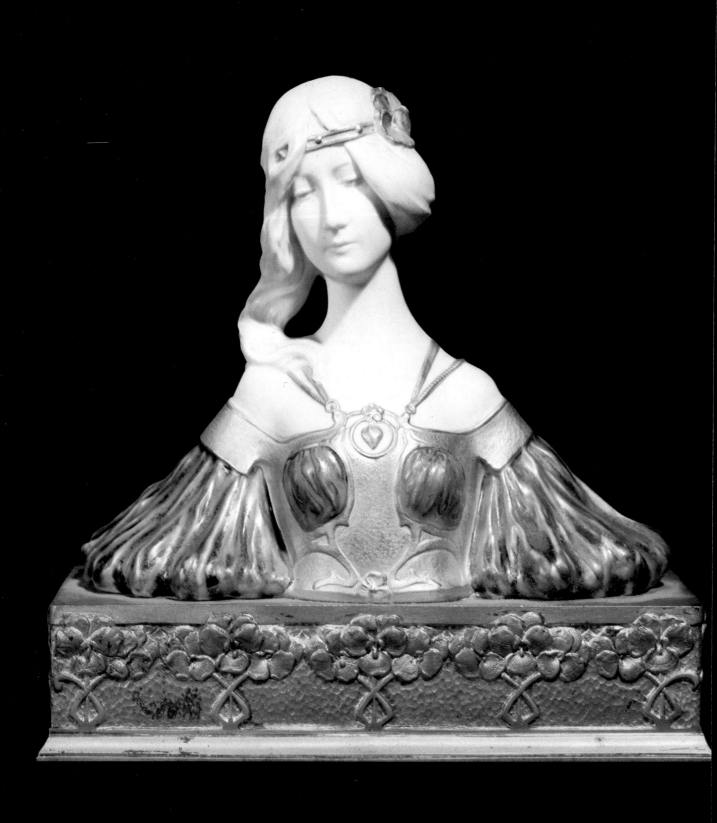

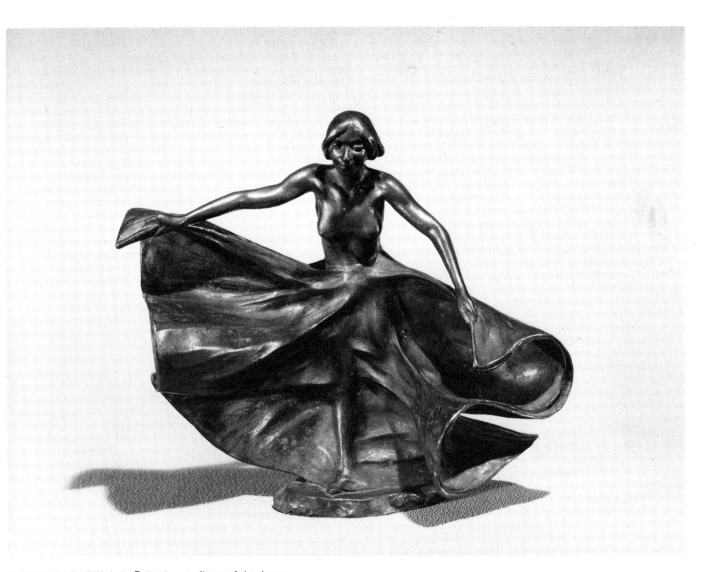

RUPERT CARABIN *Loïe Fuller* Bronze figure of the dancer.

Opposite
CHARLES KORSCHANN Glazed and unglazed ceramic bust on gilt-bronze base. (Victor Arwas collection)

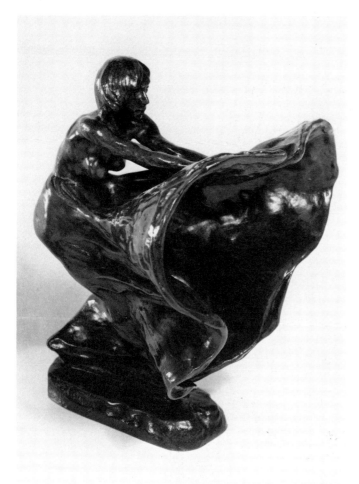

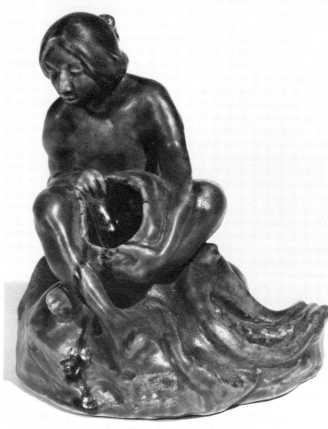

RUPERT CARABIN *Loïe Fuller* Small bronze figure of the dancer. (Macklowe Gallery)

RUPERT CARABIN *Femme à la pieuvre* (Woman with Octopus) Ceramic Inkwell.

RUPERT CARABIN *Femme accroupie* (Crouching Woman) Ceramic covered box.

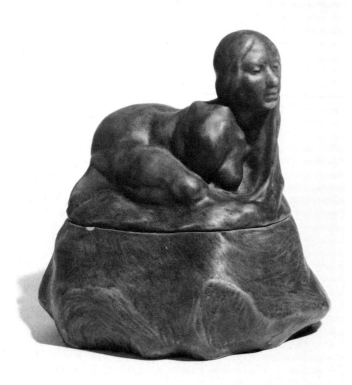

Opposite

RUPERT CARABIN *Femme chauve-souris* (Bat-woman) Bronze with bat-woman's wings forming a receptacle. (Félix Marcilhac)

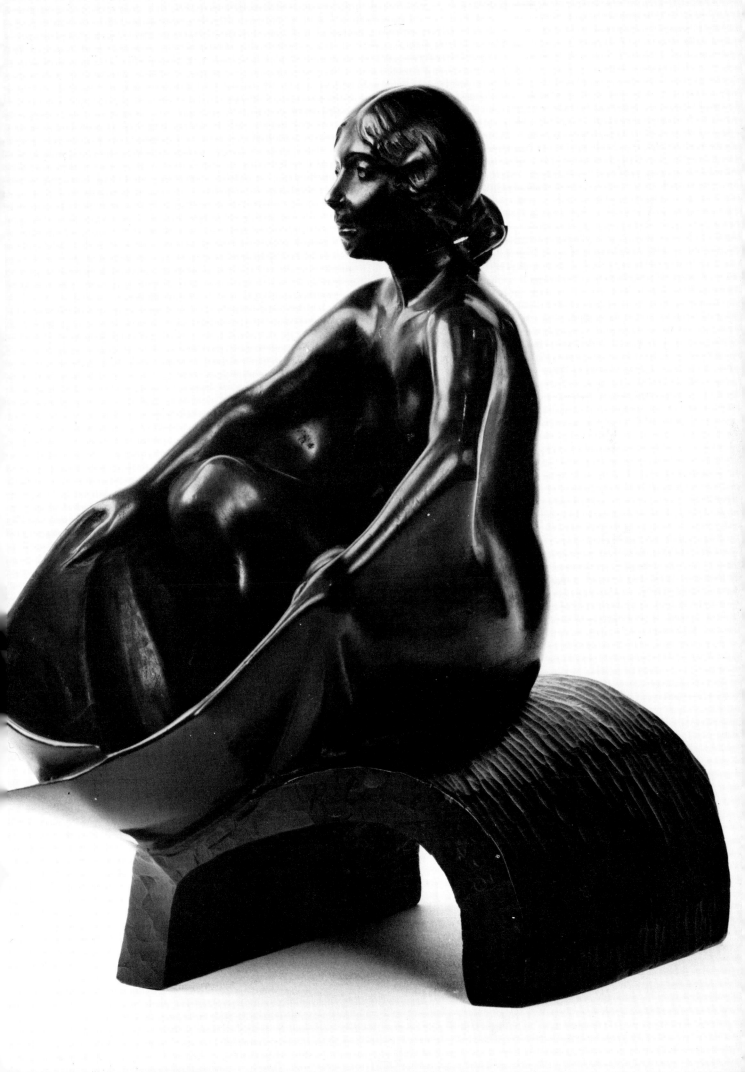

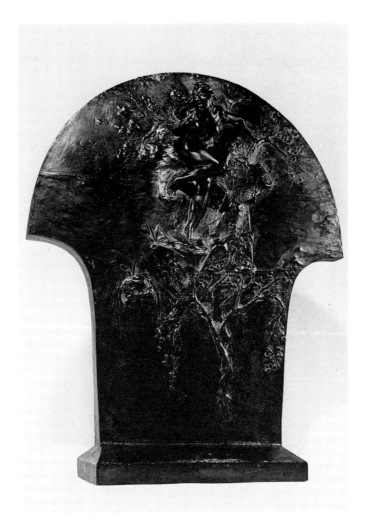

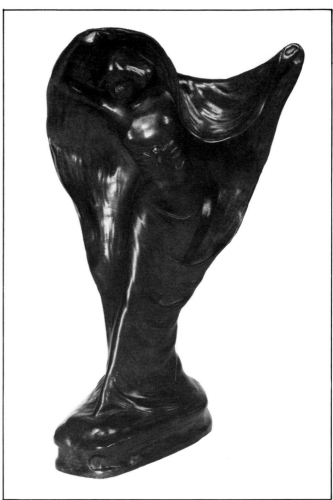

RENE LALIQUE Bronze stela with a nude woman in full relief. (Félix Marcilhac)

MICAEL-LEVY *Loïe Fuller* Bronze figure. (Mr. and Mrs. Victor Bacon)

Opposite
GEORGES-HENRY LEMAIRE Multi-media figure of a winged woman. The head, shoulders and feet are in alabaster, the dress in labradorite, the scarf in gilt-bronze and the wings in *plique-à-jour* enamel. The figure is supported on a rose quartz stand which in turn is mounted on a mottled green marble base. (Macklowe Gallery)

22

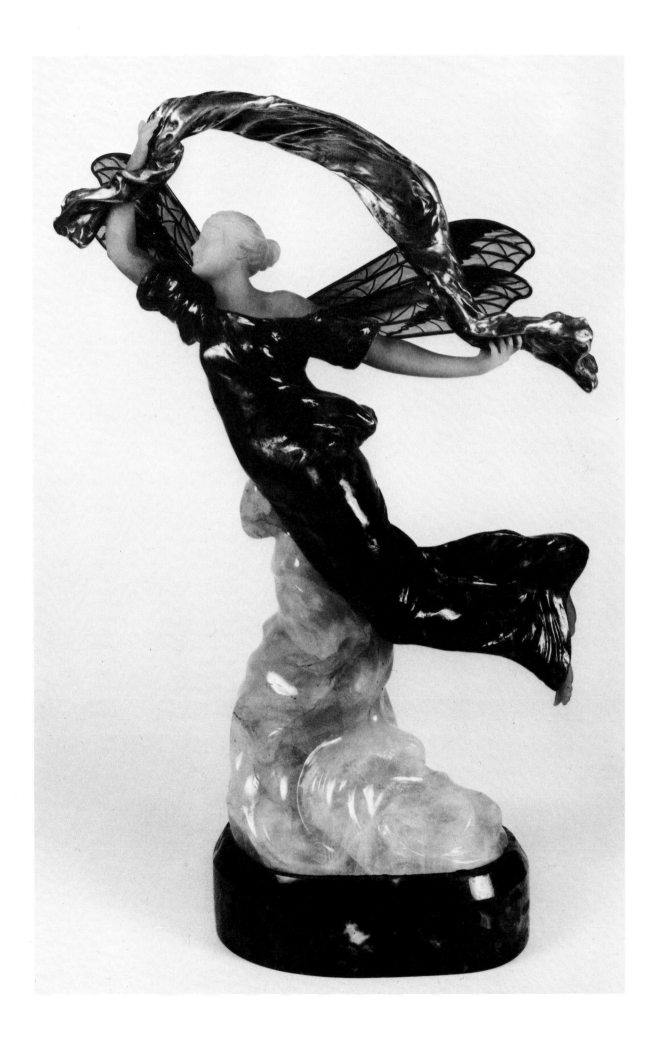

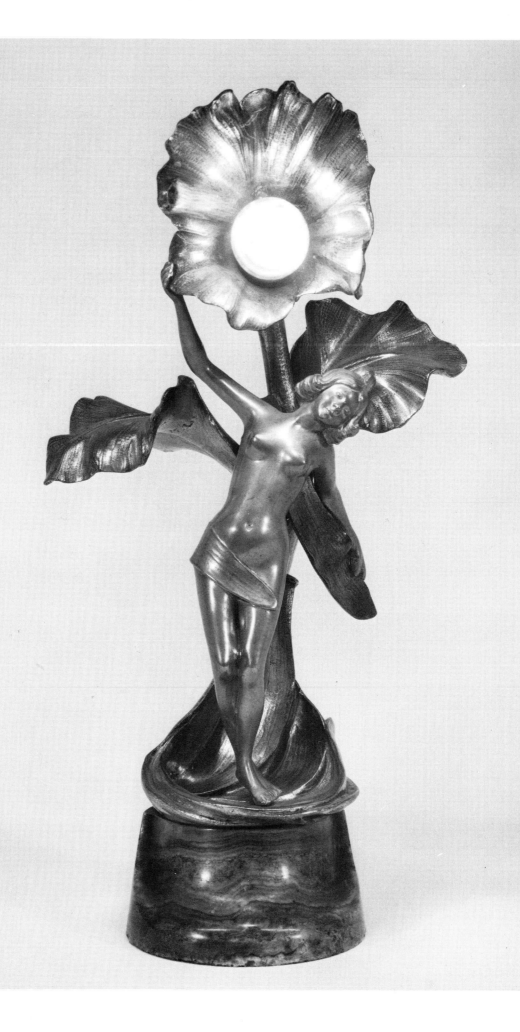

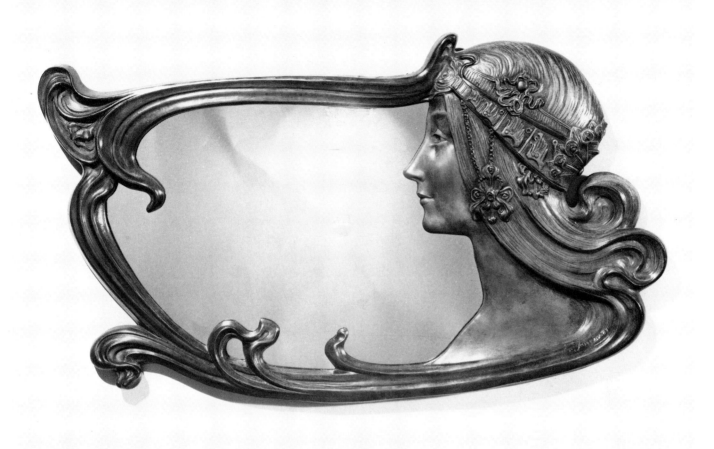

E. JONCHERY *Tête byzantine* (Byzantine head) Cast metal mirror frame with a bronze finish.

Opposite

E. JONCHERY *Femme-fleur* (Flower-woman) Gilt-bronze table lamp,
exhibited at the 1901 Salon of the Société des Artistes Français.

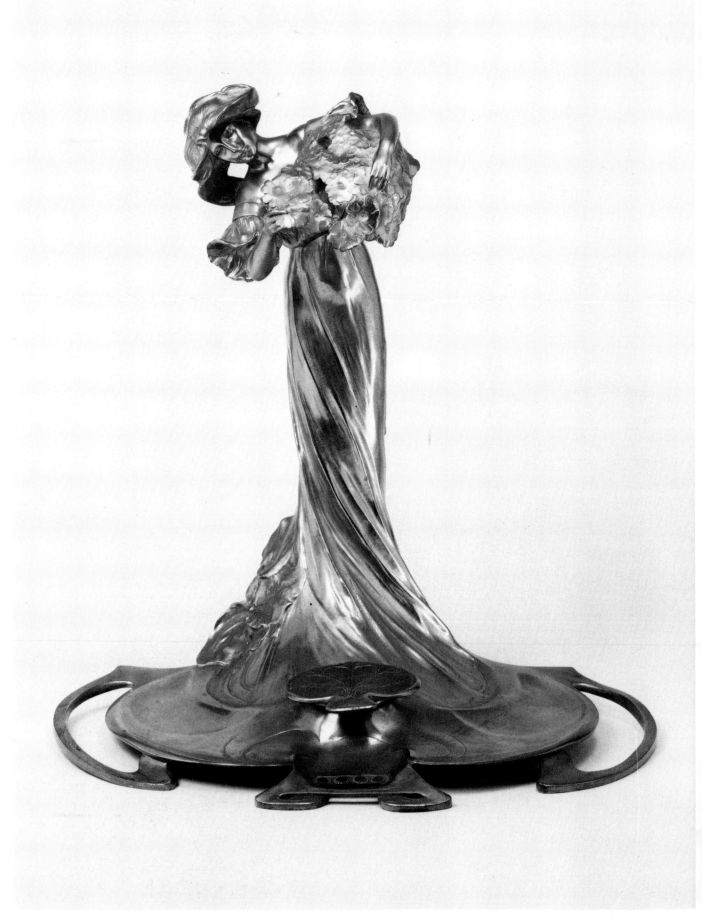

CHARLES KORSCHANN Gilt-bronze combination lamp and inkwell. (Sydney and Frances Lewis)

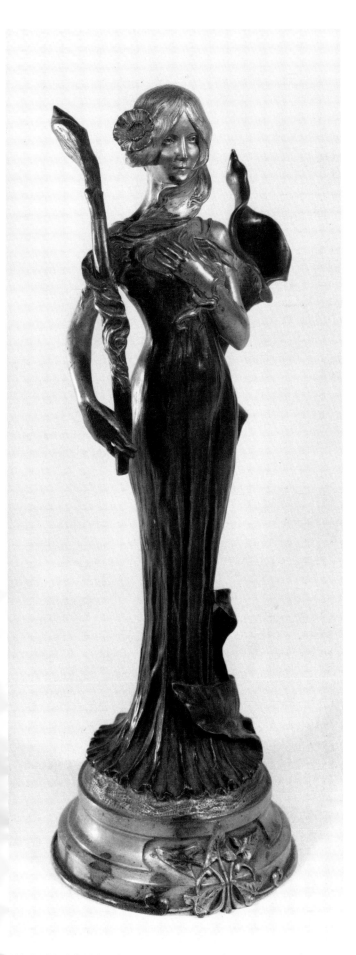

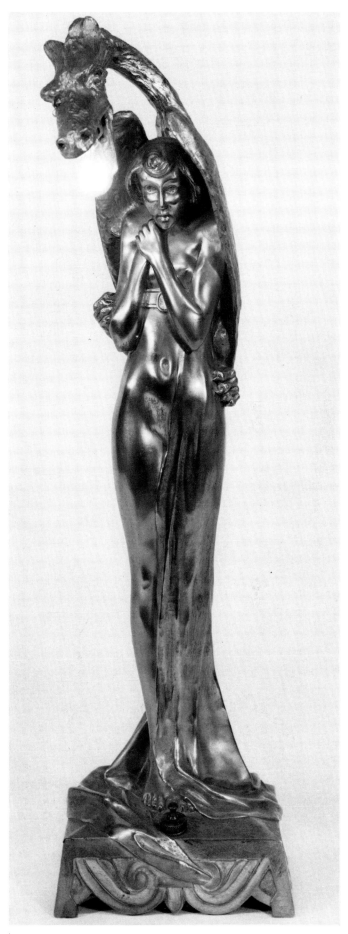

CHARLES KORSCHANN Bronze figure of a woman with lilies. (Macklowe Gallery)

FIRMIN BATE Gilt-bronze table lamp.

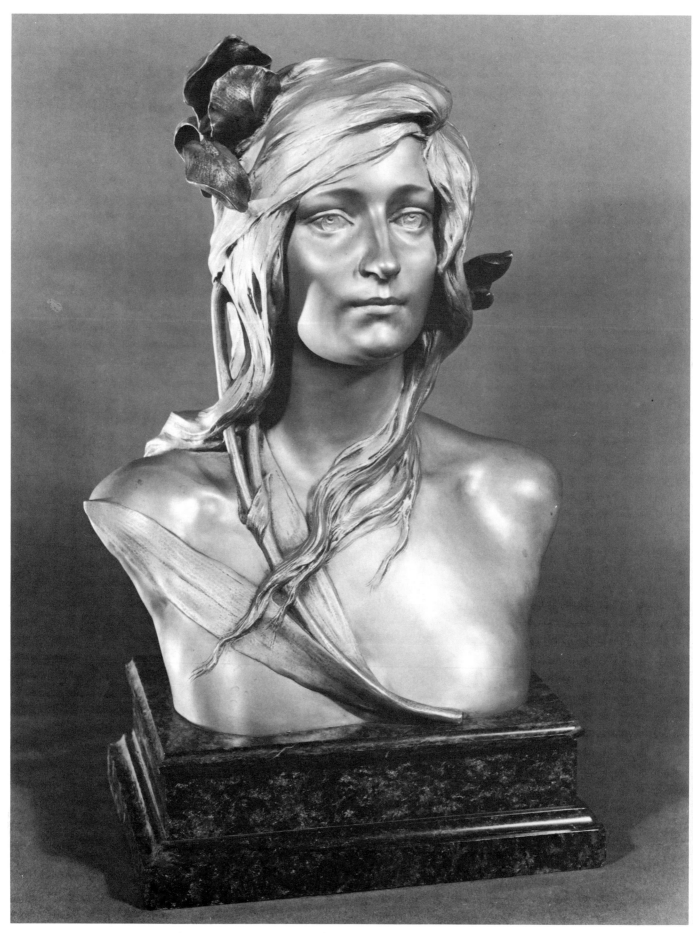

MAURICE BOUVAL Gilt-bronze bust on a marble base. (Macklowe Gallery)

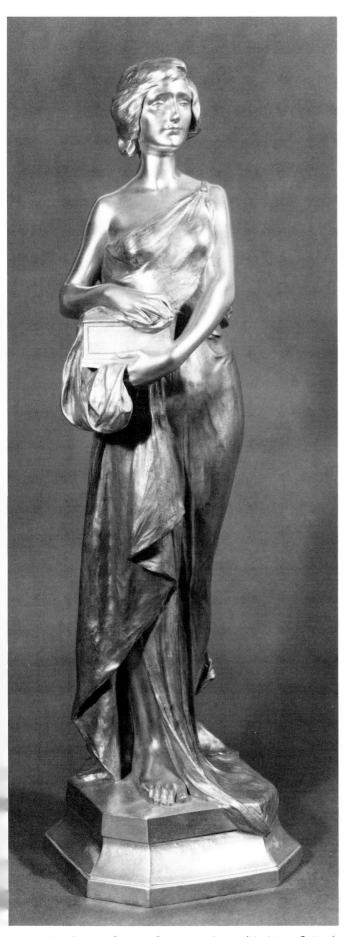

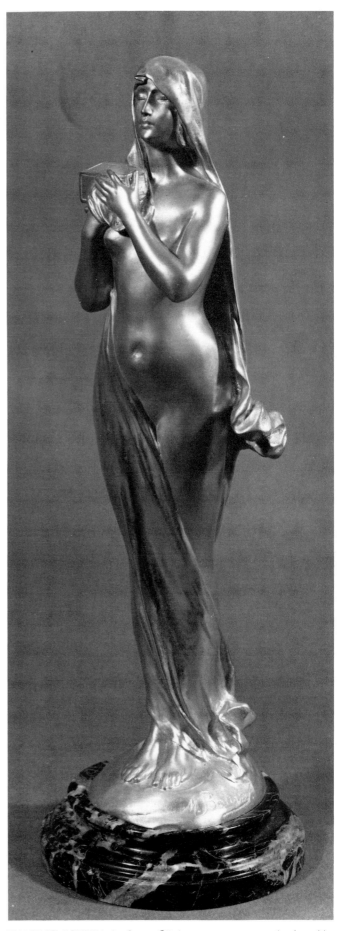

MAURICE BOUVAL *Pandora* Gilt-bronze figure. (Macklowe Gallery)

MAURICE BOUVAL *Le Secret* Gilt-bronze statue on a veined marble base. (Macklowe Gallery)

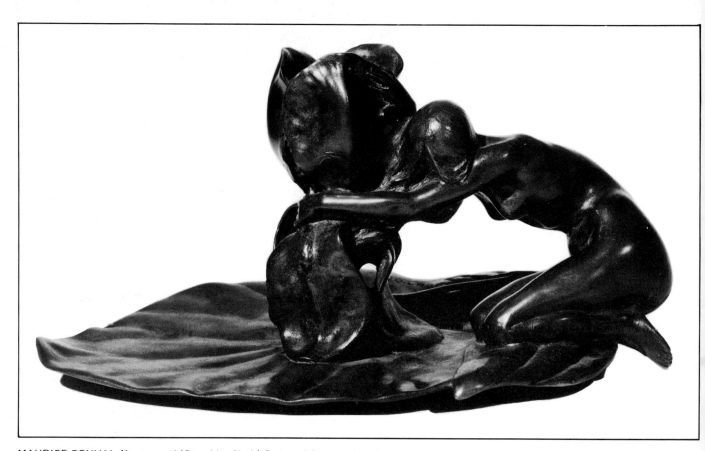

MAURICE BOUVAL *Nu accroupi* (Crouching Nude) Patinated bronze inkwell.

Opposite
MAURICE BOUVAL Gilt-bronze covered jar. Foundry mark of Jollet.
(Macklowe Gallery)

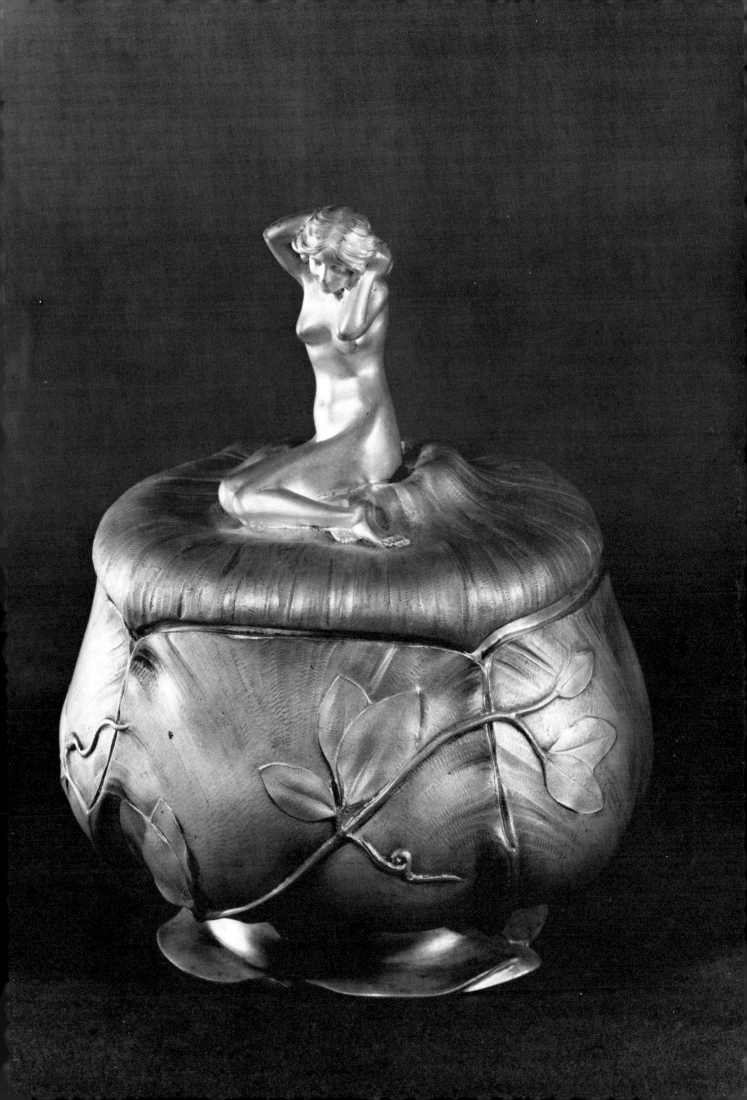

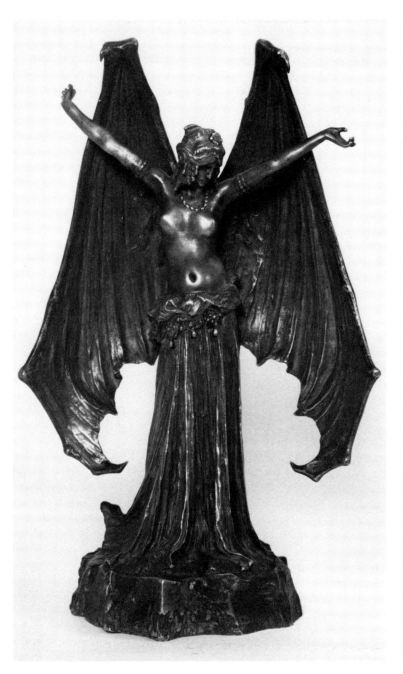

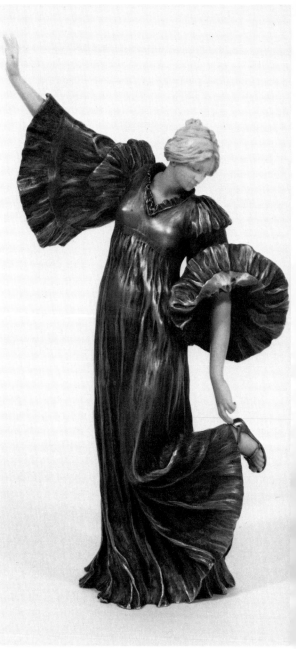

AGATHON LEONARD *Femme chauve-souris* (Bat-woman) Bronze figure. (Félix Marcilhac)

AGATHON LEONARD *La Cothurne* Bronze and ivory figure from the series *Le Jeu de l'écharpe*.

Opposite
AGATHON LEONARD Gilt-bronze and marble bust on a marble plinth base. (Sotheby's Belgravia)

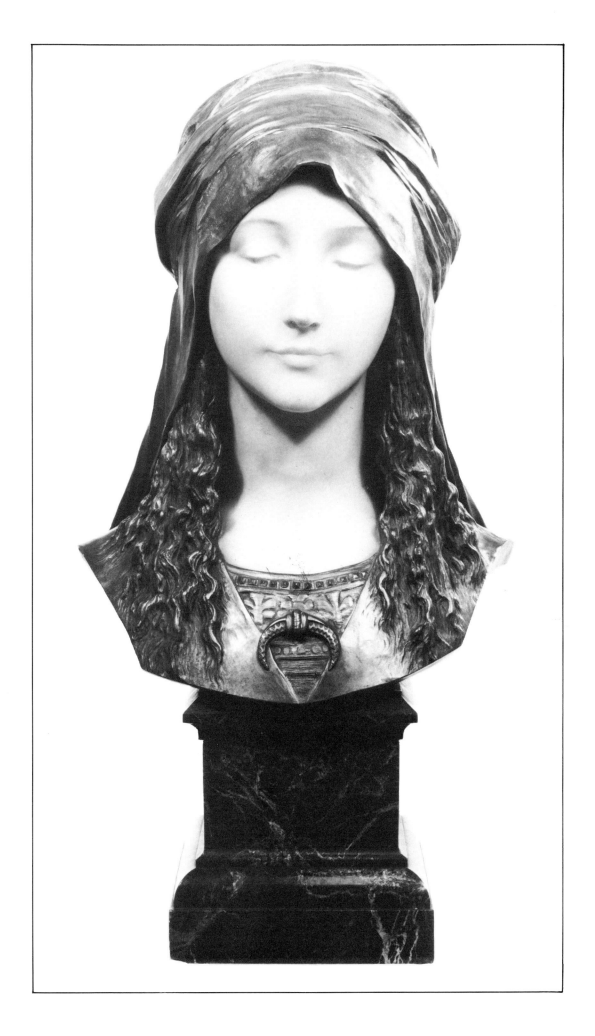

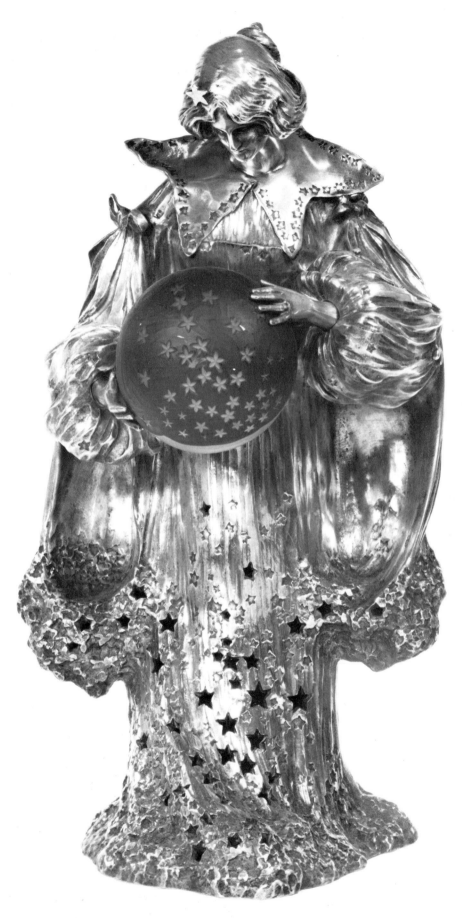

LEO LAPORTE-BLAIRSY *La Voie lactée* (The Milky Way) Silvered
bronze figure holding a blue and opal glass globe acid-etched with stars.
The globe executed by Daum Frères at Nancy.

Opposite
LEO LAPORTE-BLAIRSY *La Fée au coffret* (Fairy with Casket)
Bronze figure with filigreed stained glass, fitted for electricity.

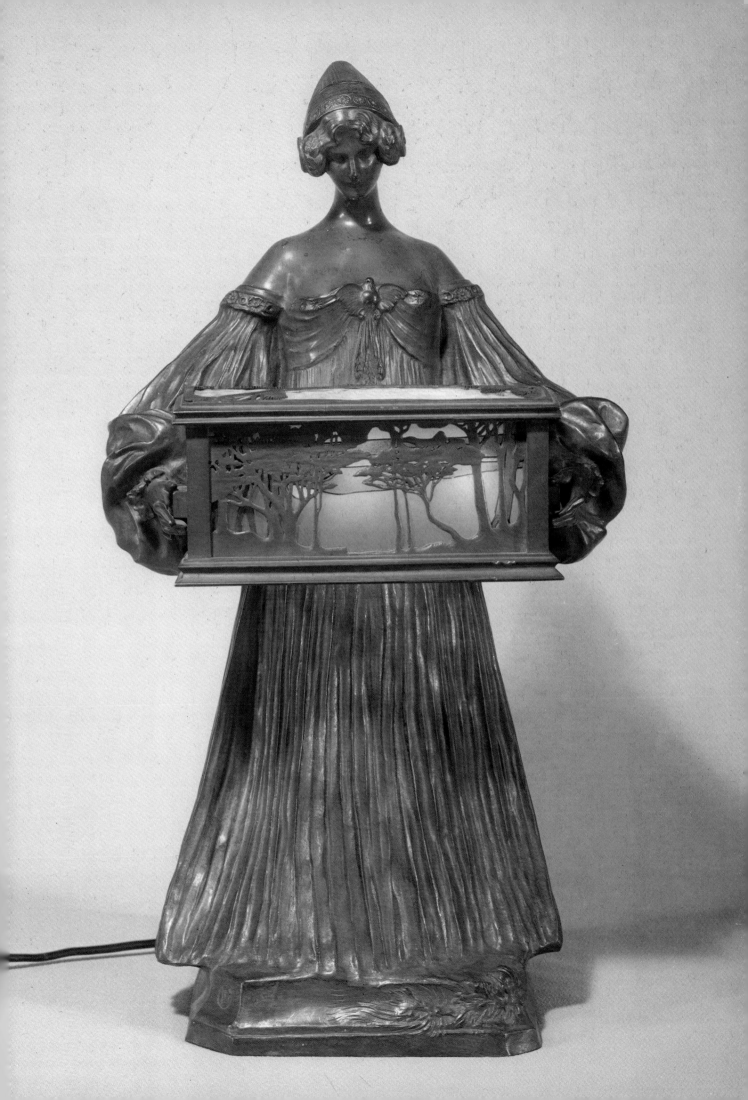

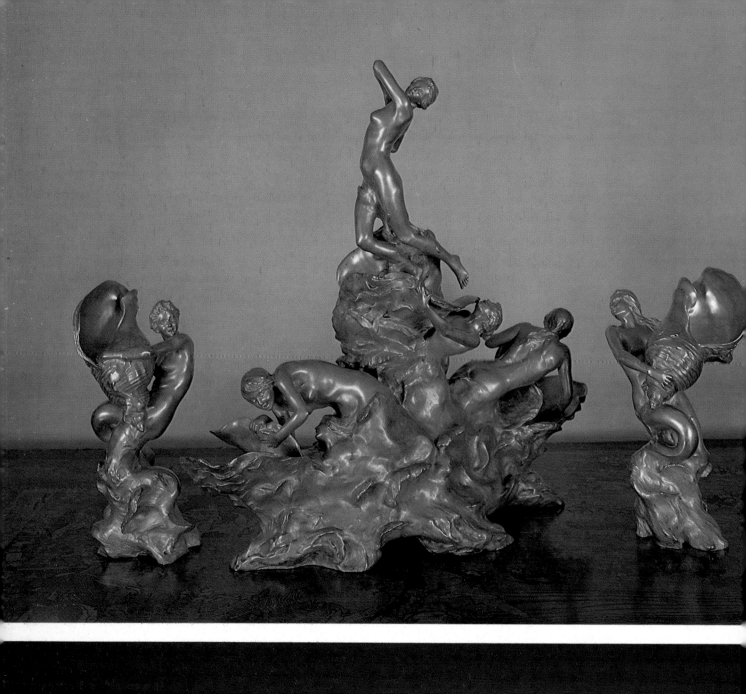

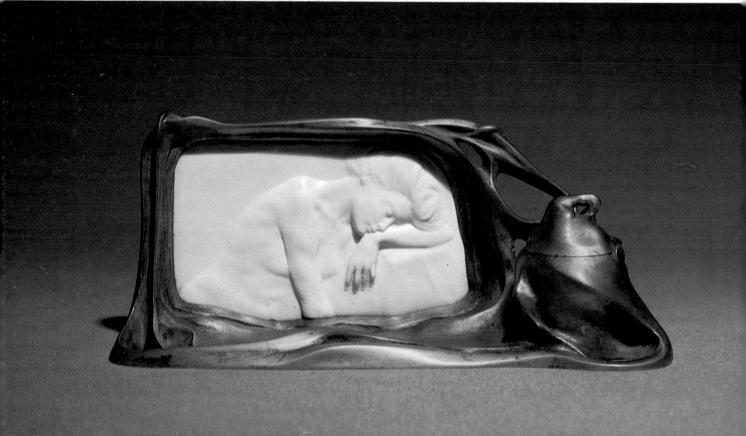

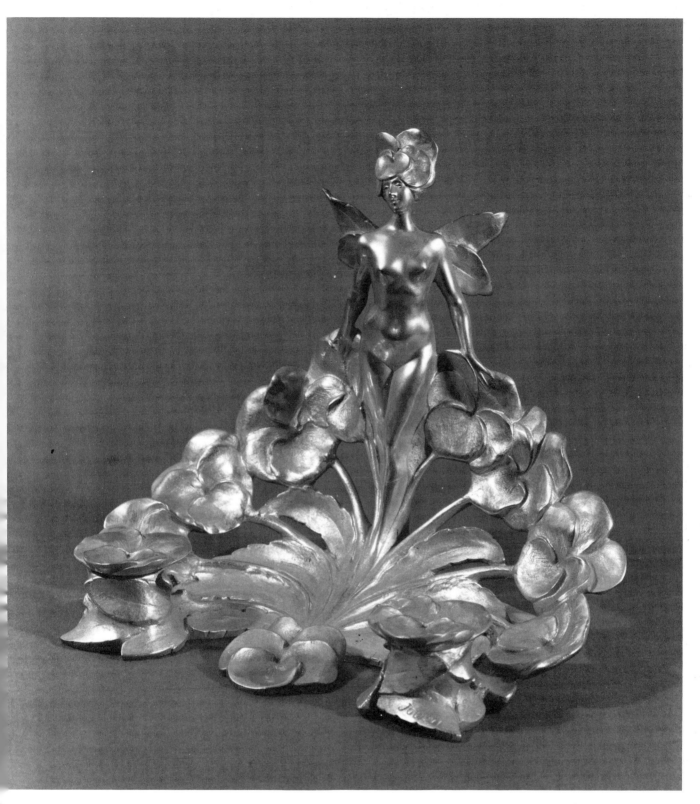

JULES JOUANT Gilt-bronze twin inkwell. (Macklowe Gallery)

opposite above
RAOUL LARCHE An important gilt-bronze three piece *surtout de table,* c.1897. An identical set, illustrated in *Art et Décoration,* July-December 1897, is now in the Darmstadt Hessischen Landesmuseum. (Private collection)

opposite below
CHAUVET Patinated bronze inkwell with inset carved ivory panel. (Victor Arwas collection)

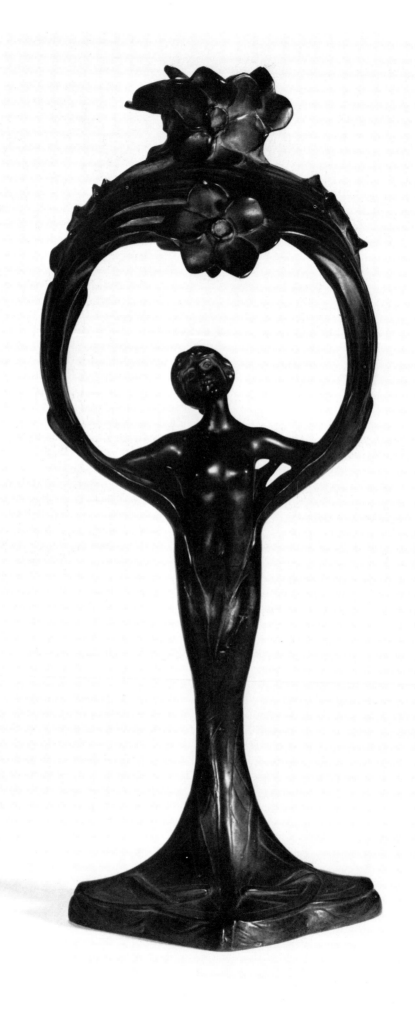

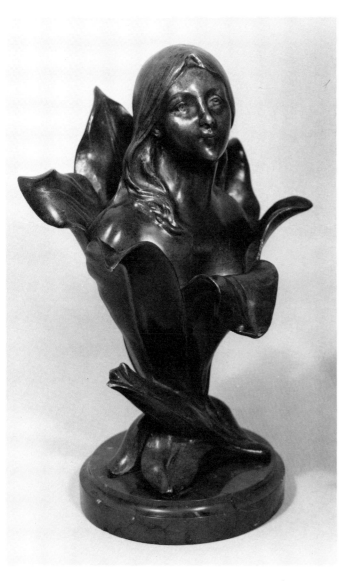

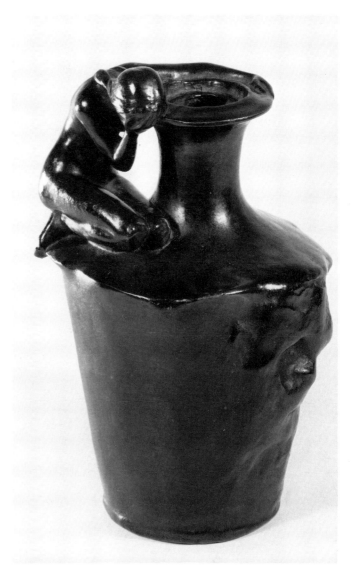

HENRI GODET Bronze statuette of a young woman emerging from an Easter lily, on a marble base. (Macklowe Gallery)

VILLE VALLGREN Bronze patinated jug, dated 1892. (Macklowe Gallery)

Opposite
JULES JOUANT Bronze table lamp, c. 1900. Jouant exhibited through the Salon des Beaux-Arts from 1896-1904. (Chrysler Museum at Norfolk)

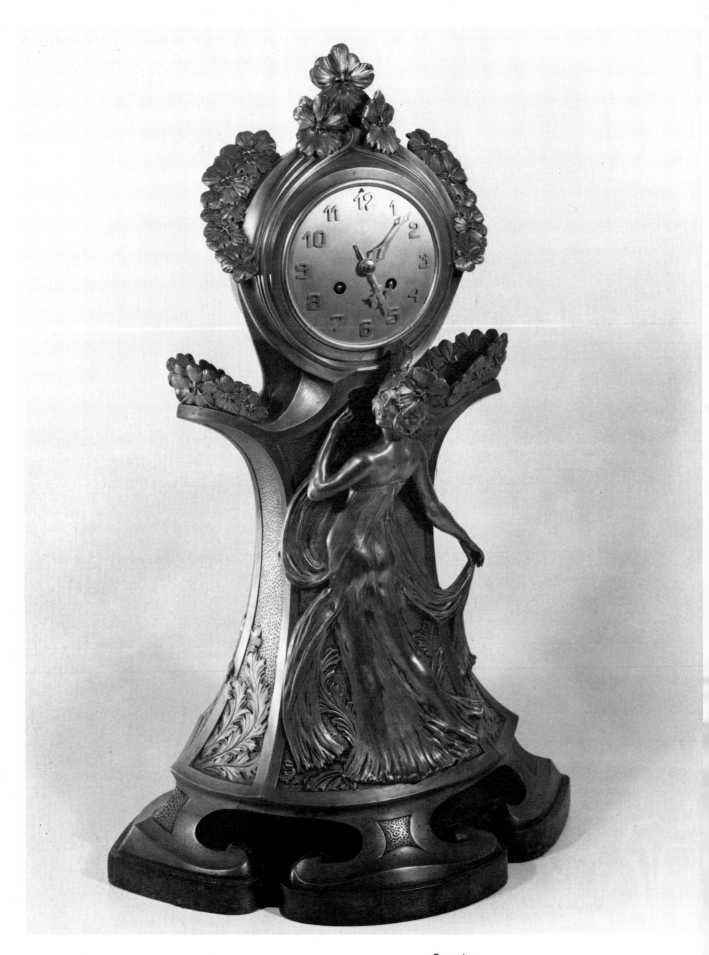

LOUIS CHALON Mantel garniture clock in gilt-bronze. (Macklowe Gallery)

Opposite
LOUIS CHALON Gilt-bronze statuette. (Macklowe Gallery)

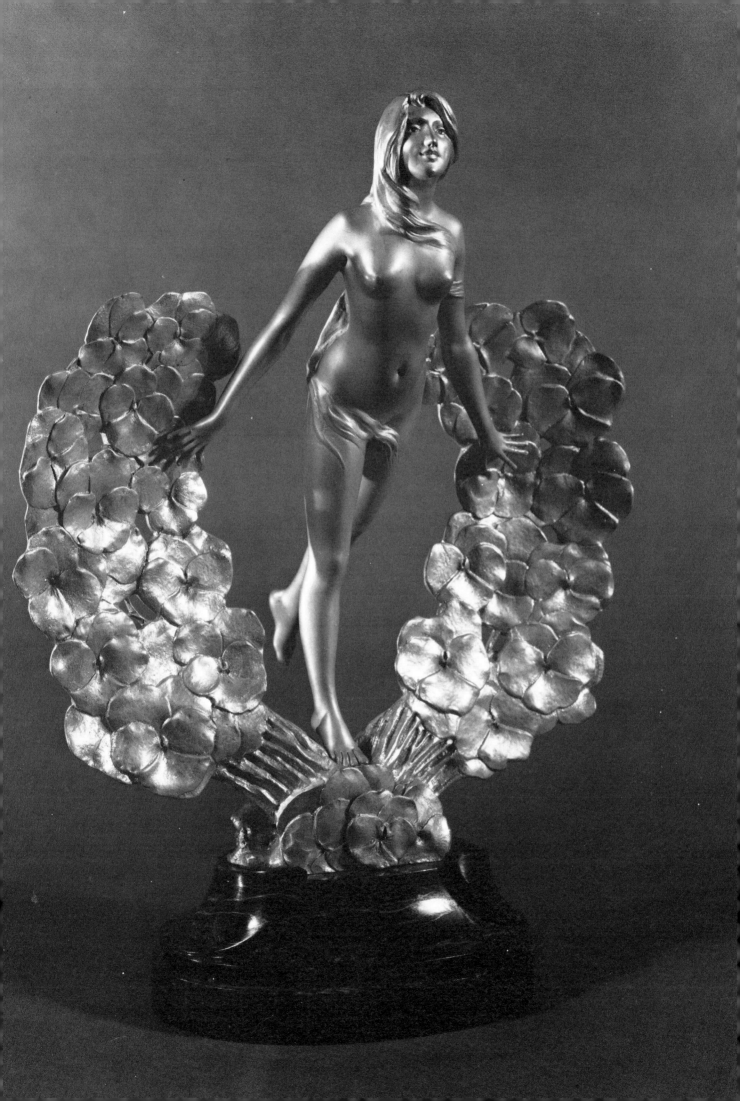

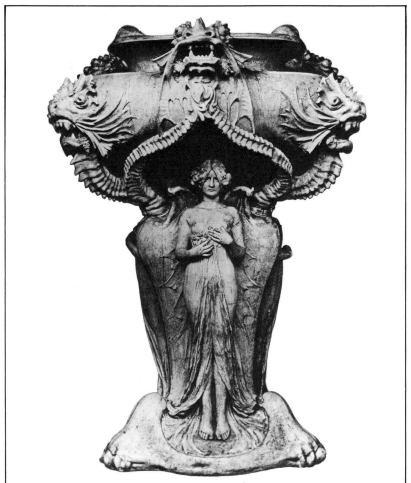

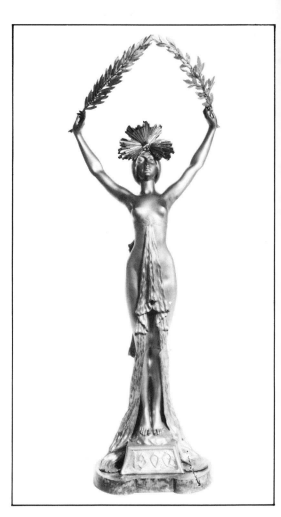

LOUIS CHALON *Les Hesperides* Seven foot high garden vase executed for Chalon in earthenware by Emile Muller and shown at the 1900 Universal Exhibition. The three daughters of Atlas support the sea monsters which guarded the garden of the Hesperides.

LOUIS CHALON *1900* Symbolic gilt-bronze statuette of the new century. (Sotheby's Belgravia)

Opposite
RAOUL LARCHE *La Tempête et les nuées* (Storm-clouds) This group was first shown at the 1899 Salon of the Société des Artistes Français, and again at the 1900 Universal Exhibition. (Macklowe Gallery)

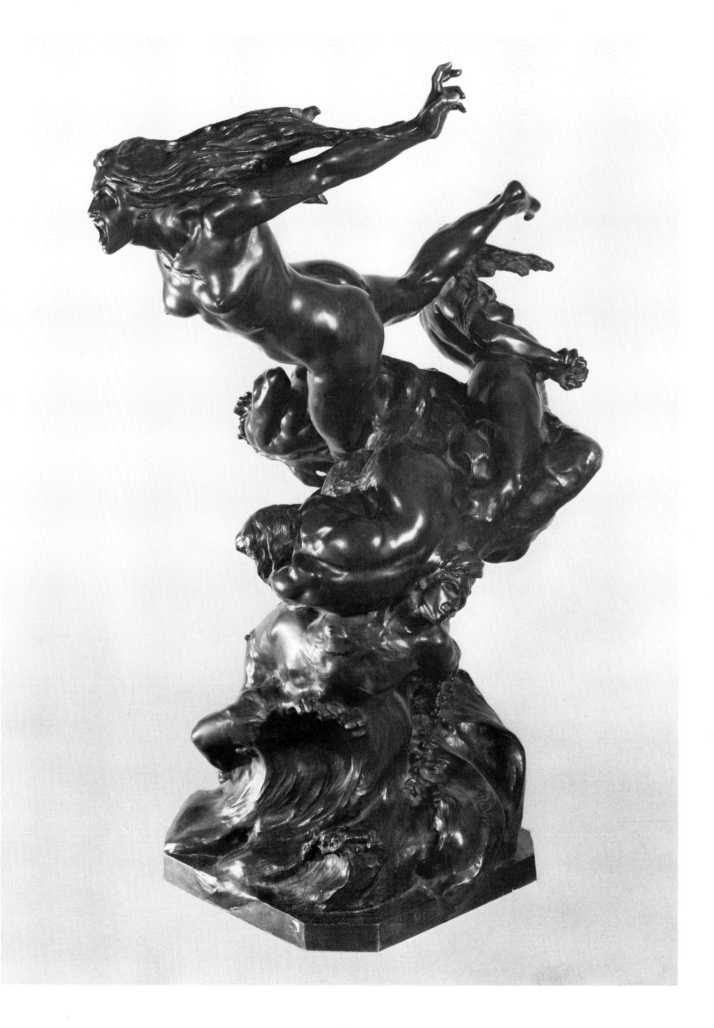

43

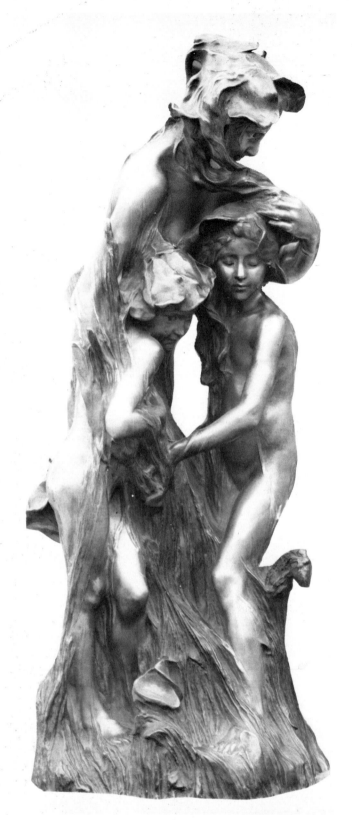

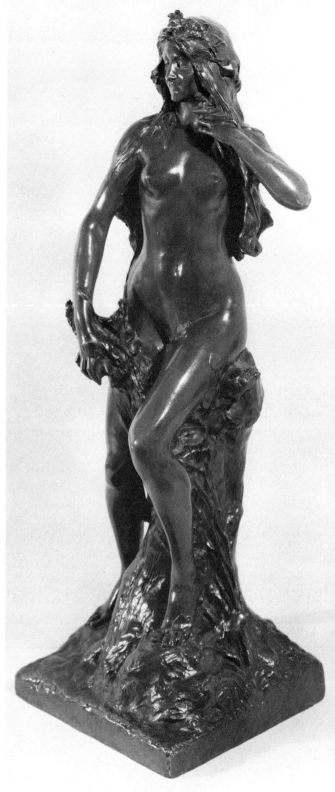

RAOUL LARCHE *Les Violettes* Bronze group, 1904. (Félix Marcilhac)

RAOUL LARCHE Patinated bronze statue. Foundry mark of Susse Frères, Paris. (Macklowe Gallery)

Opposite
RAOUL LARCHE *Loïe Fuller* Gilt bronze figure with concealed lighting.

Page 46
BORSE *Cléo de Mérode* Silvered bronze portrait bust of one of the great beauties of the time. (Victor Arwas collection)

Page 47
HENRI GODET *Femme-fleur* (Flower-woman) Patinated and enamelled bronze figure on marble base. (Victor Arwas collection)

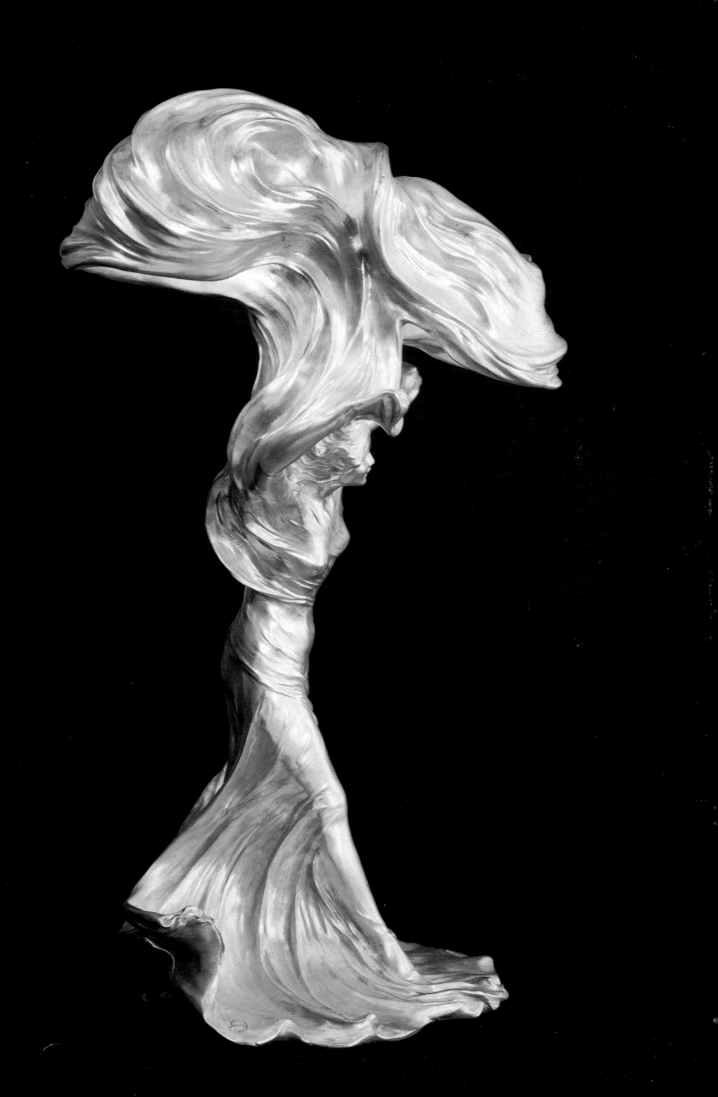

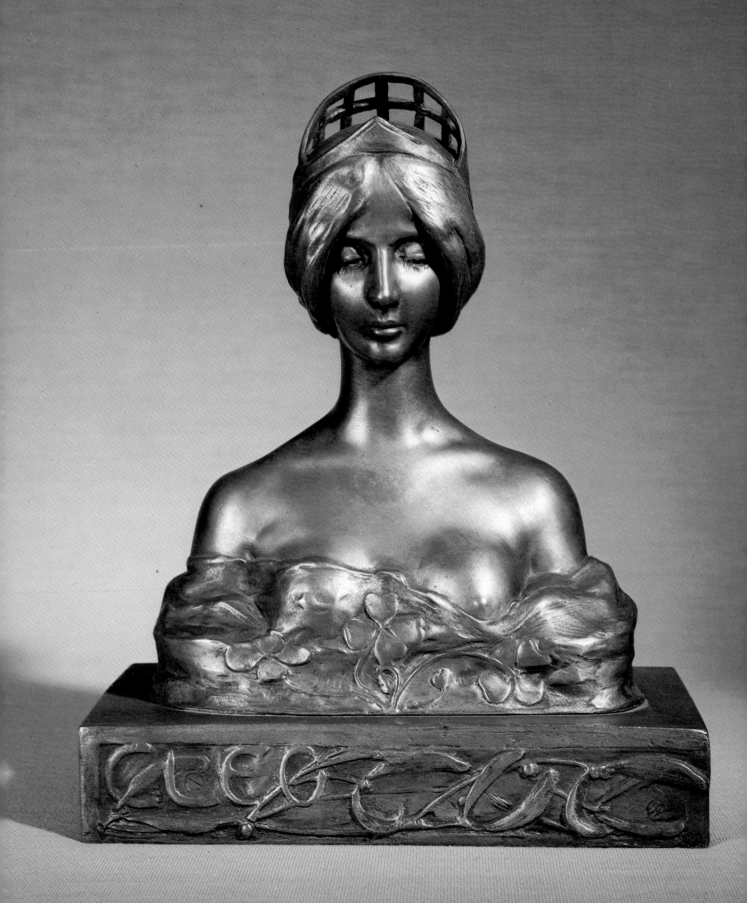

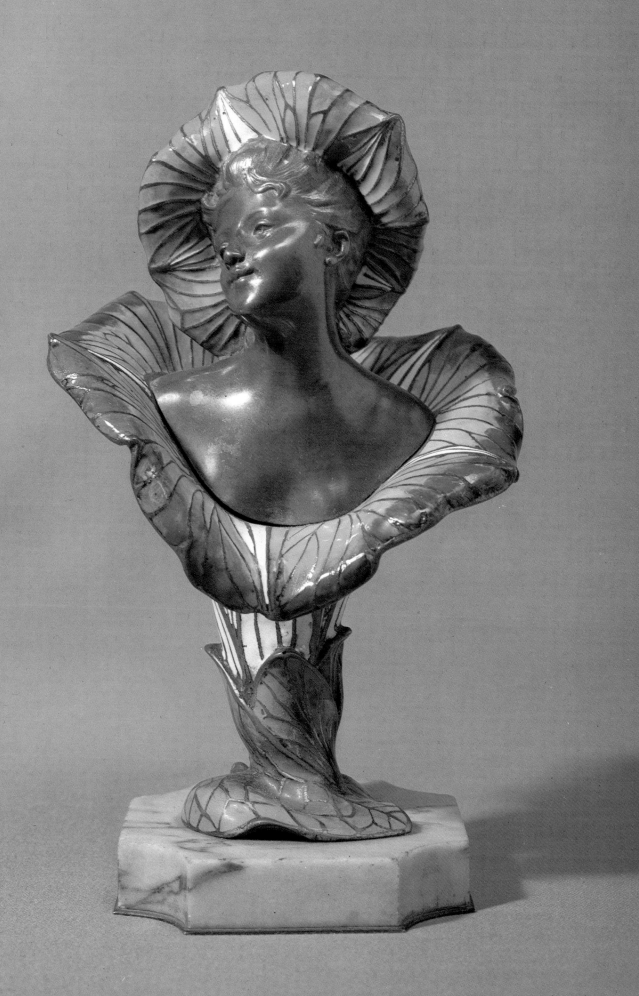

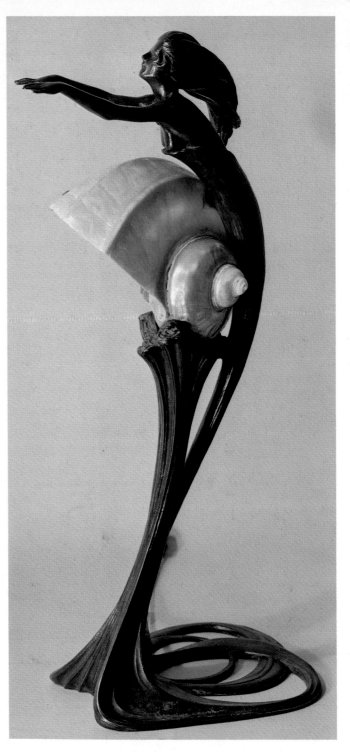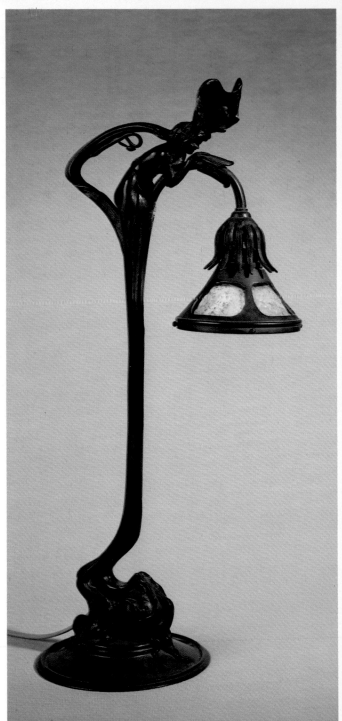

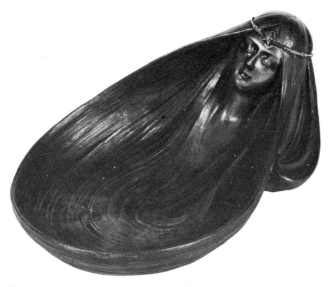

GUSTAV GURSCHNER Bronze pintray, the woman's headband set
with a diamond. (Sydney and Frances Lewis)

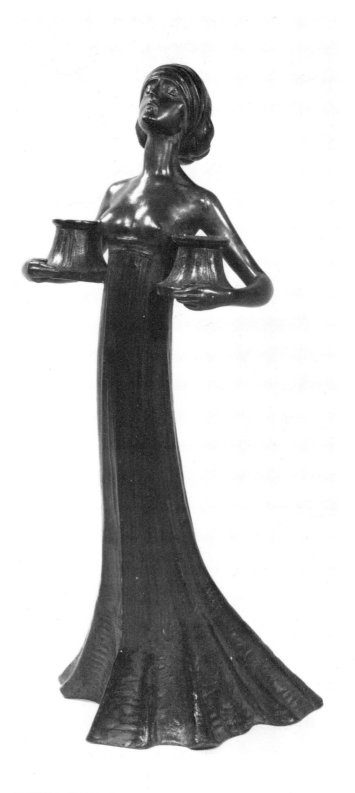

GUSTAV GURSCHNER Bronze two-light candelabrum. (Christie's)

Opposite left
GUSTAV GURSCHNER Bronze and Turbo Marmoratus shell table
lamp, 1899. (Macklowe Gallery)

Opposite right
GUSTAV GURSCHNER Patinated bronze lamp, the shade fitted with
iridescent Tiffany glass panels.

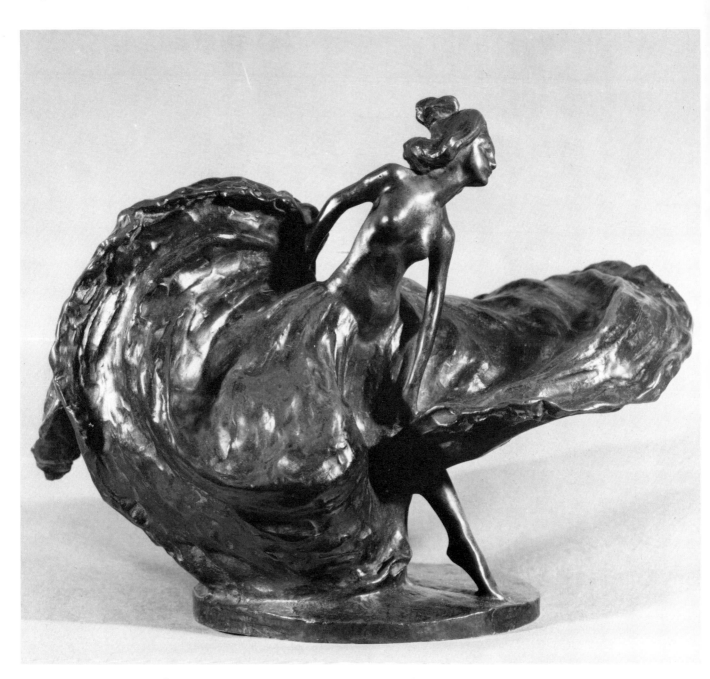

BERNHARD HOETGER *Loïe Fuller* A rare bronze figure of the dancer. (Mrs. F. Pratt)

Opposite
THEODORE RIVIERE *Loïe Fuller* Bronze figure of the dancer, shown swirling her veils.

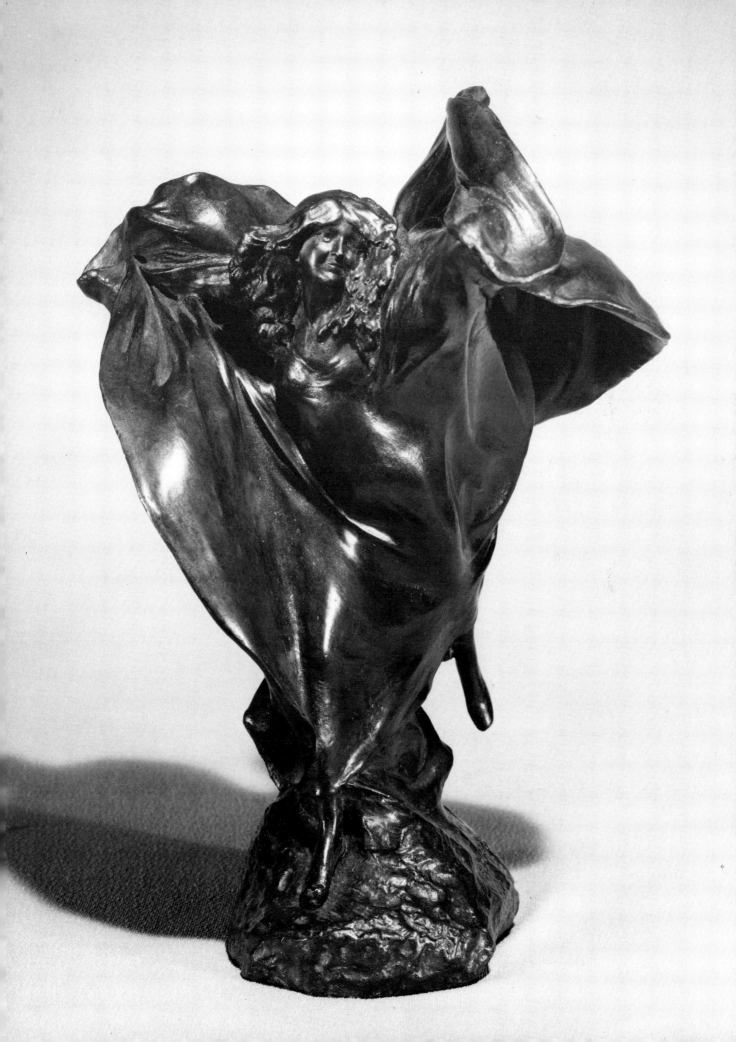

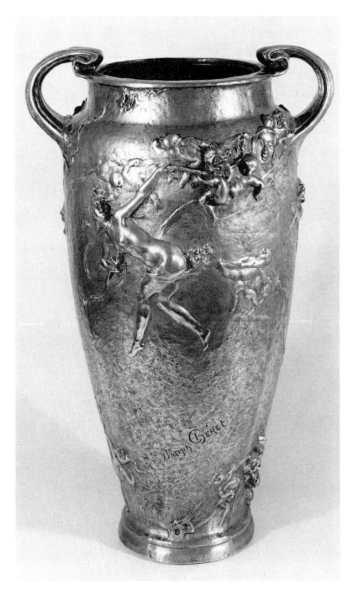

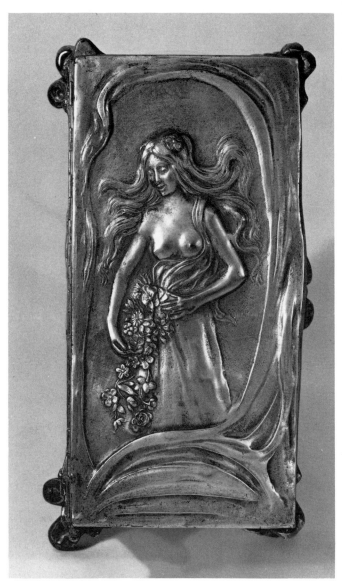

JOSEPH CHERET Silvered bronze vase with nymph and putti in high and low relief. Chéret died in 1894 but a number of his original models were later recast by the founder Soleau, some as late as 1904. (Macklowe Gallery)

RAOUL RAMONDEAU Silvered bronze casket, each panel modelled with a different image.

Opposite
JOSEPH CHERET *Libellule* (Dragon-fly) Gilt-bronze tray.

52

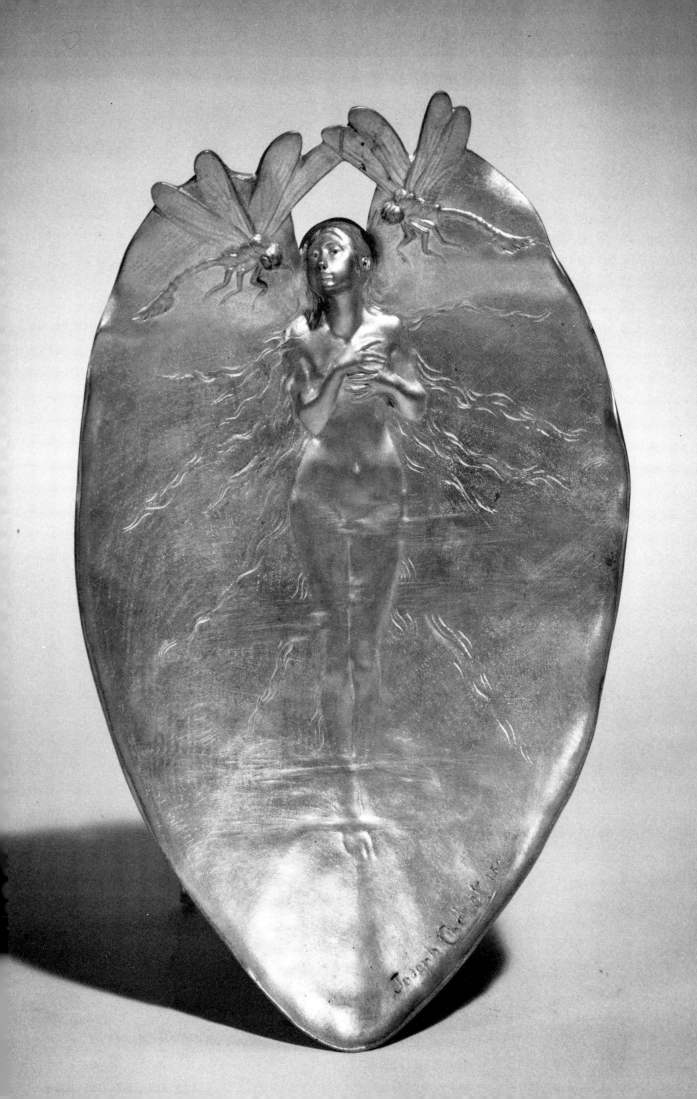

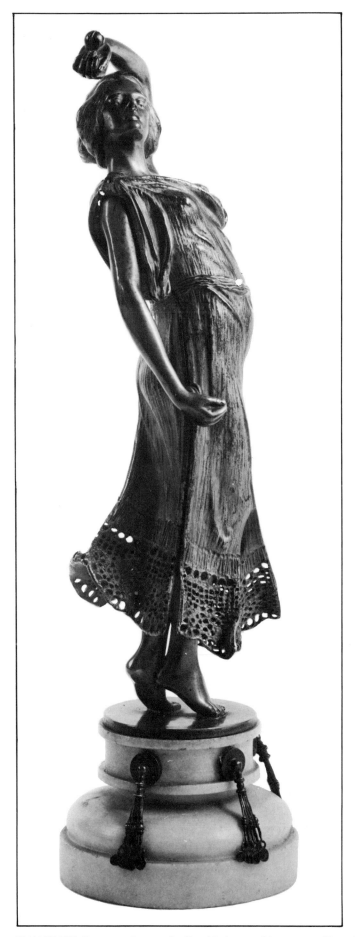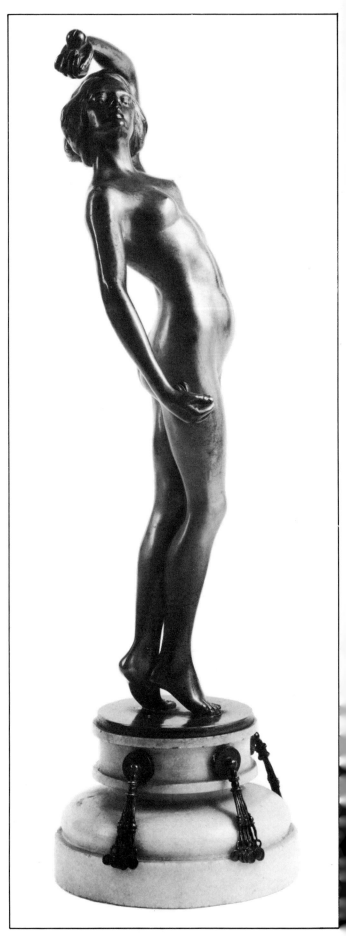

MAX KLEIN Bronze sculpture of a Spanish dancer with castanets. Her robe is removable. (Félix Marcilhac)

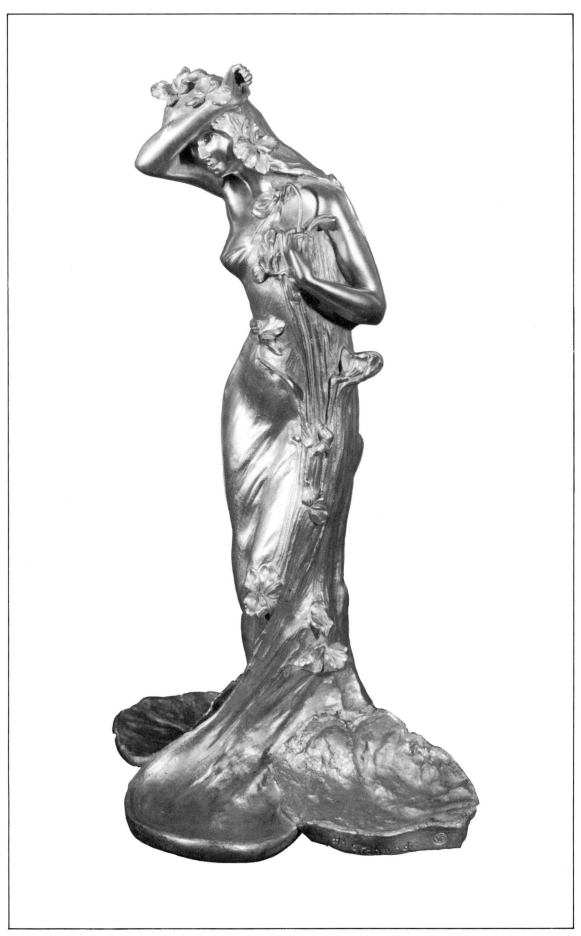

MARCHAND Gilt-bronze statuette. Foundry mark of Camus, Paris. (Macklowe Gallery)

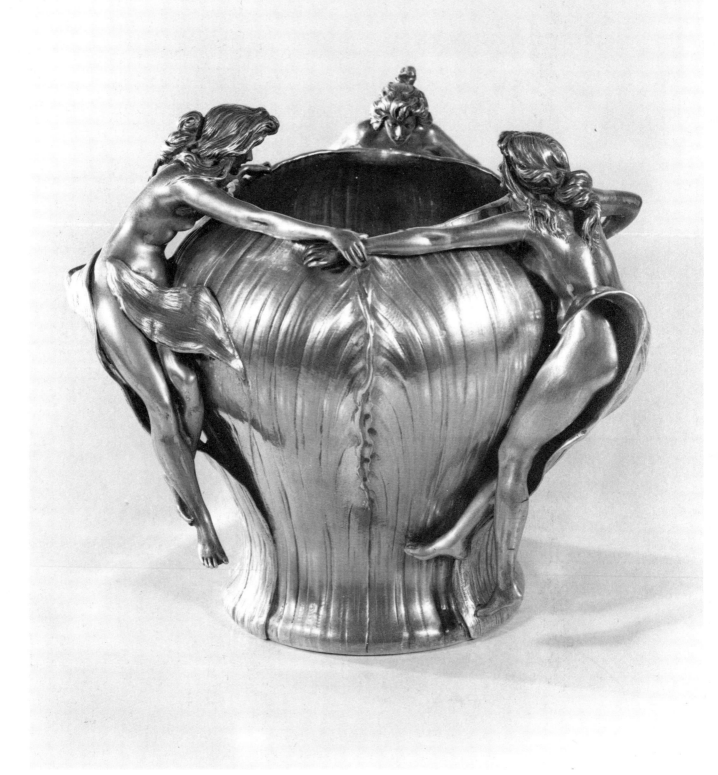

LEOPOLD SAVINE Three leaf-enveloped women on gilt-bronze bowl. (Macklowe Gallery)

Opposite
ALEXANDRE VIBERT A parcel-gilt and silvered bronze figure of a young woman. Her robe is set with enamel, bloodstones, and emerald and amethyst cabochons; the book with green onyx and moonstones; the base with enamelled plaques by George-Jean and lapis lazuli corner posts. The back bears a plaque engraved 'Prix la Grange 1906'. (Mr. and Mrs. Wilson Miller)

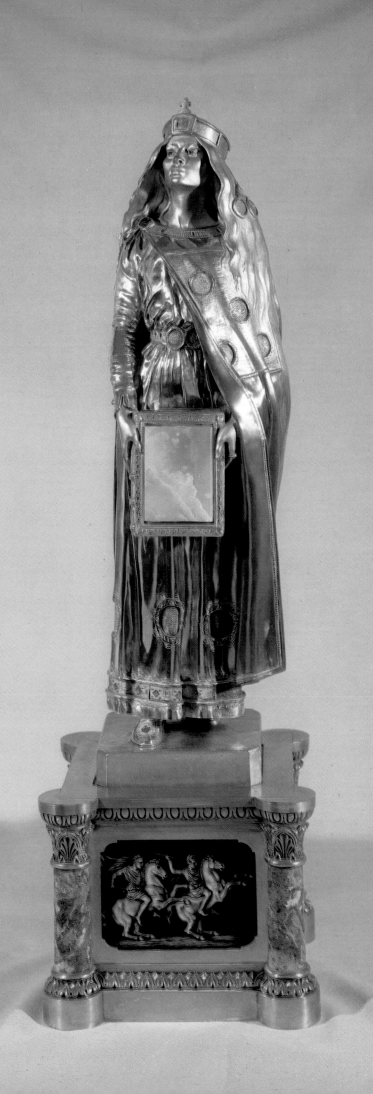

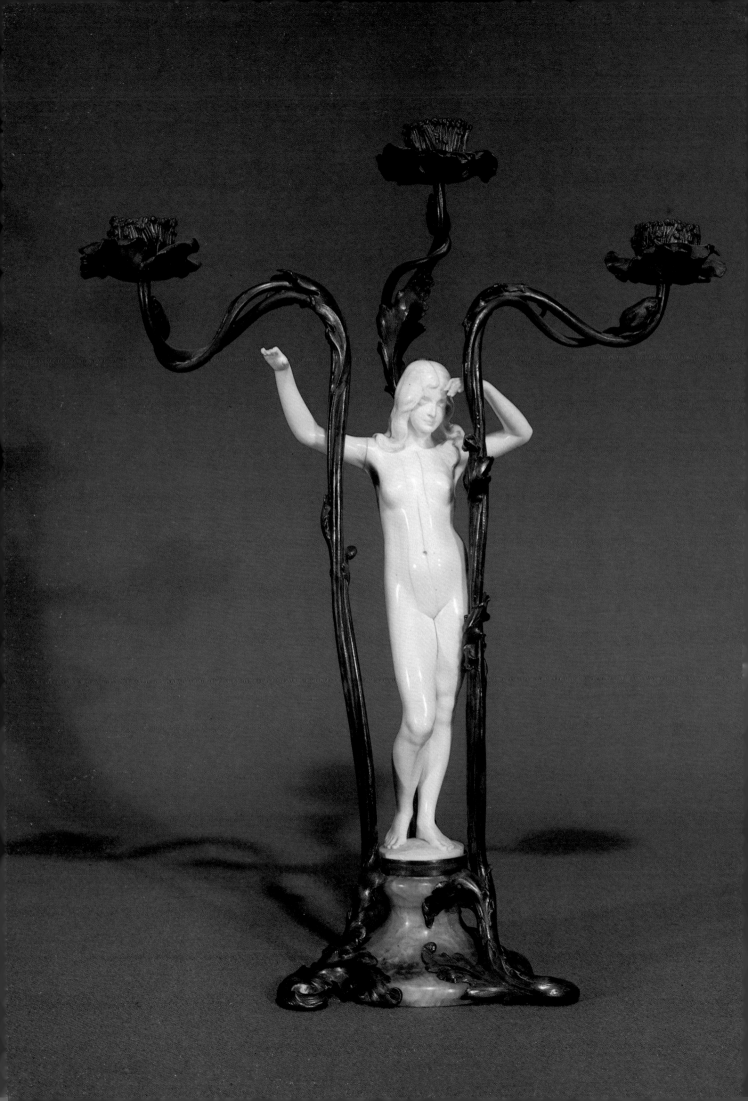

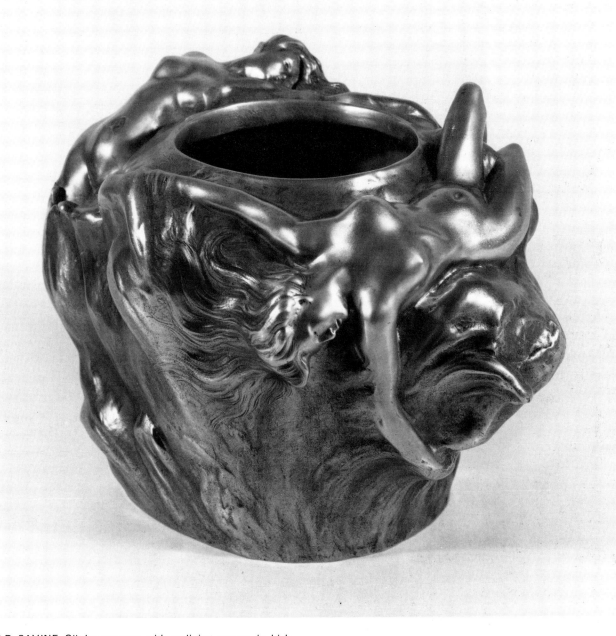

LEOPOLD SAVINE Gilt-bronze vase with reclining women in high
relief. First exhibited at the Salon of the Société des Artistes Français
in 1902. (Macklowe Gallery)

Opposite

EGIDE ROMBAUX Carved ivory figure surrounded by floral candle
holders in oxydised silver by Franz Hoosemans.

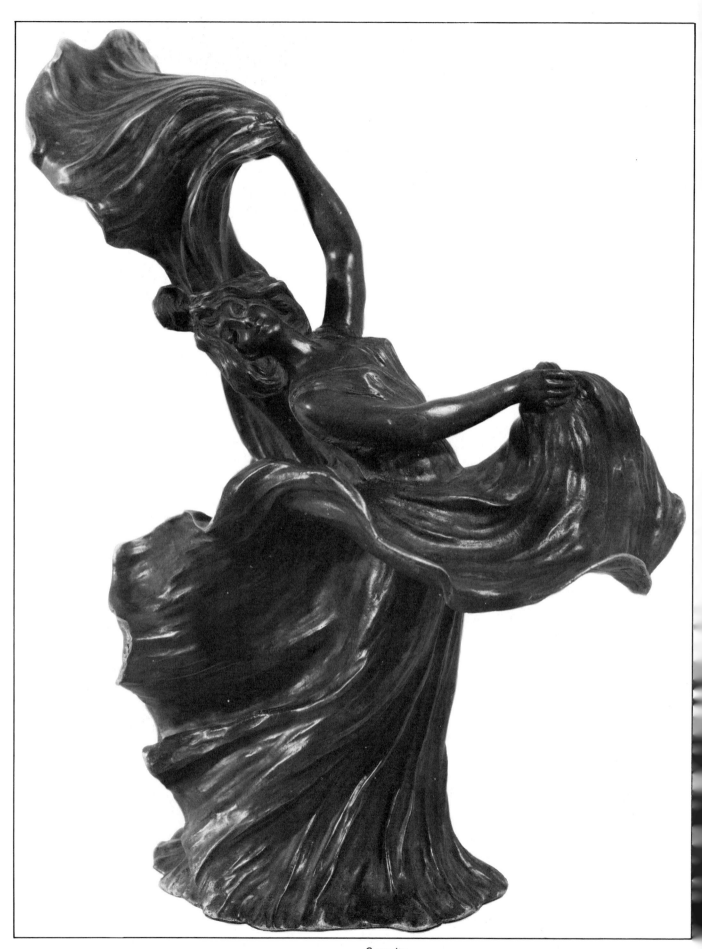

CLARA PFEFFER *Loïe Fuller* Bronze figure of the American dancer
exhibited at the 1901 Salon of the Société Nationale des Beaux-Arts.
(Macklowe Gallery)

Opposite
CLARA PFEFFER Marble and silvered bronze plaque of young woman
holding a tablet. (Macklowe Gallery)

60

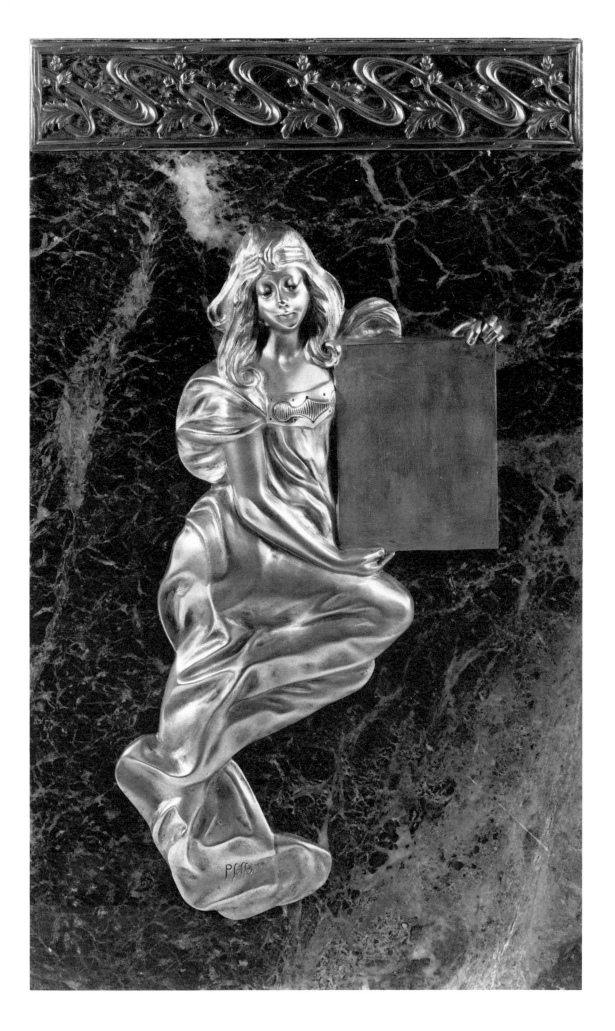

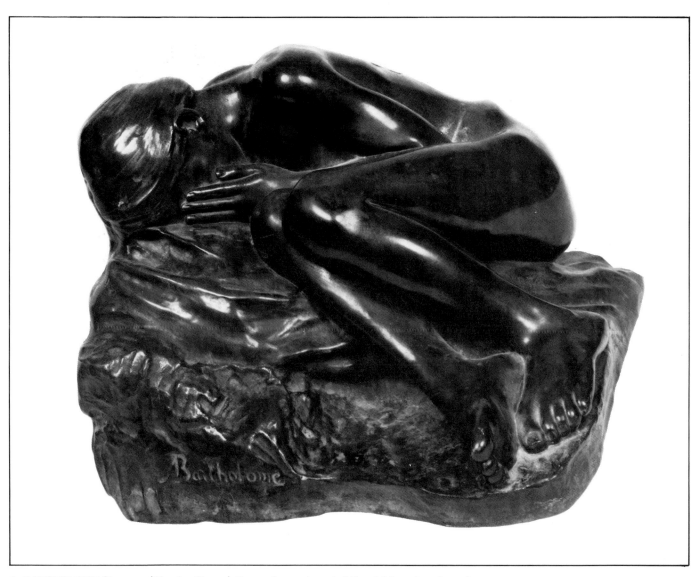

A. BARTHOLOME *Pleureuse* (Weeping Woman) Bronze figure, characteristic of this sculptor's work.

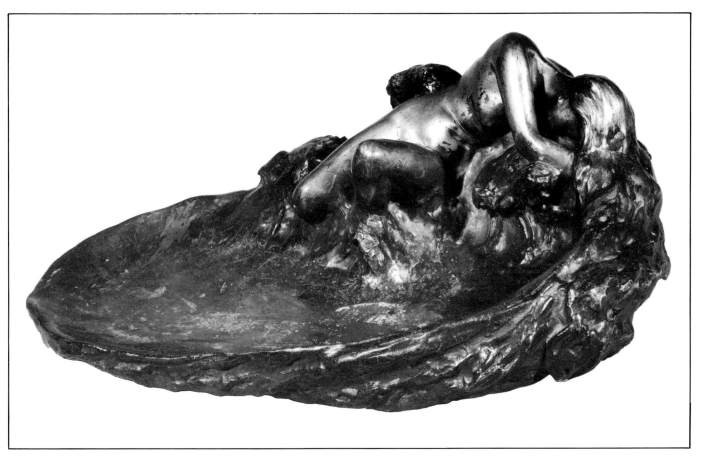

JEANNE ITASSE *Naufragée* (Shipwrecked) Bronze figure.

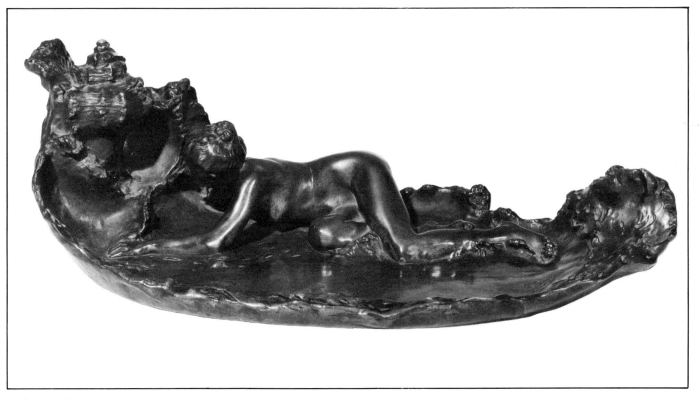

AUGUSTE LEDRU Bronze inkwell with pentray.

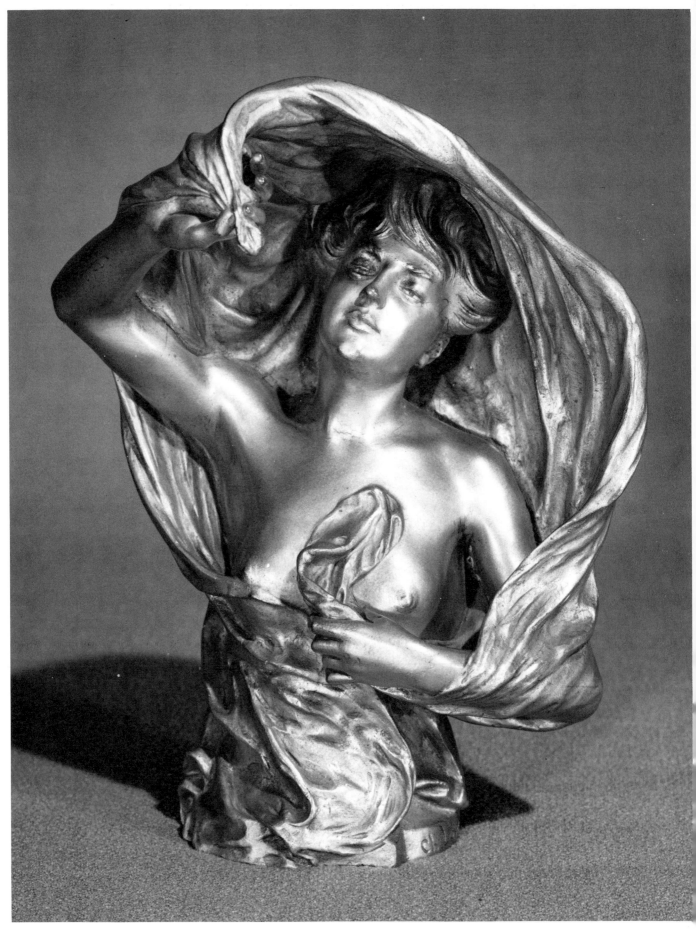

CHARLES LOUCHET *Loïe Fuller* Gilt bronze bust.

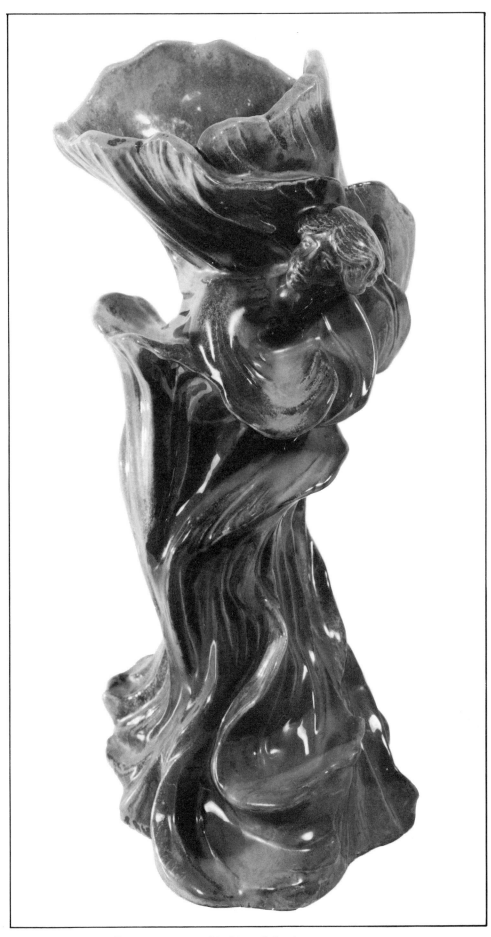

R. JEANDELLE *Loïe Fuller* Ceramic vase. (Macklowe Gallery)

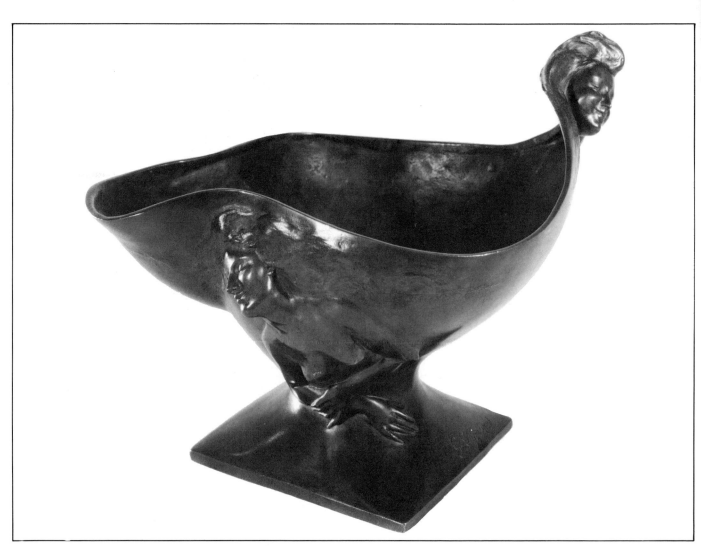

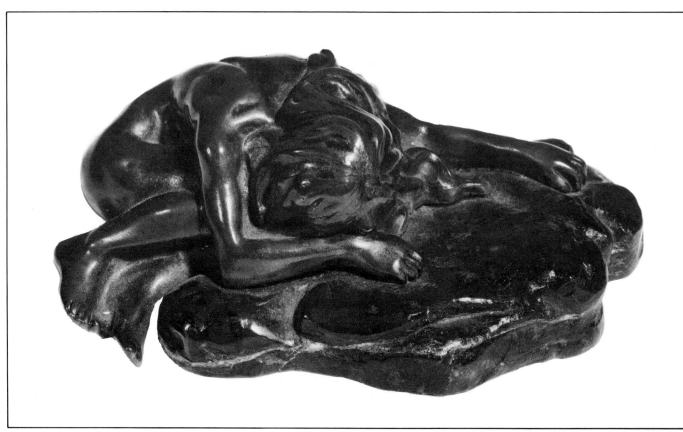

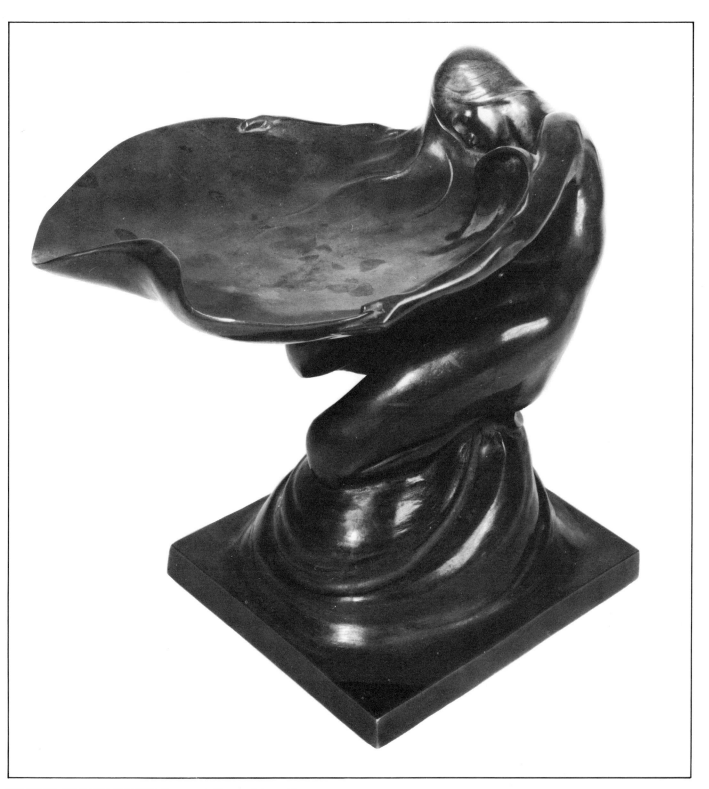

WILHELM WANDSCHNEIDER Bronze visiting-card tray, Vienna, c. 1900. (Mr. and Mrs. Victor Bacon)

Opposite above
GEORGES ENGRAND Bronze centrepiece dish, first exhibited at the 1902 Salon of the Société des Artistes Français. (Macklowe Gallery)

Opposite below
MARCEL BING Bronze and carved granite. Marcel was the son of Samuel Bing, founder of L'Art Nouveau gallery.

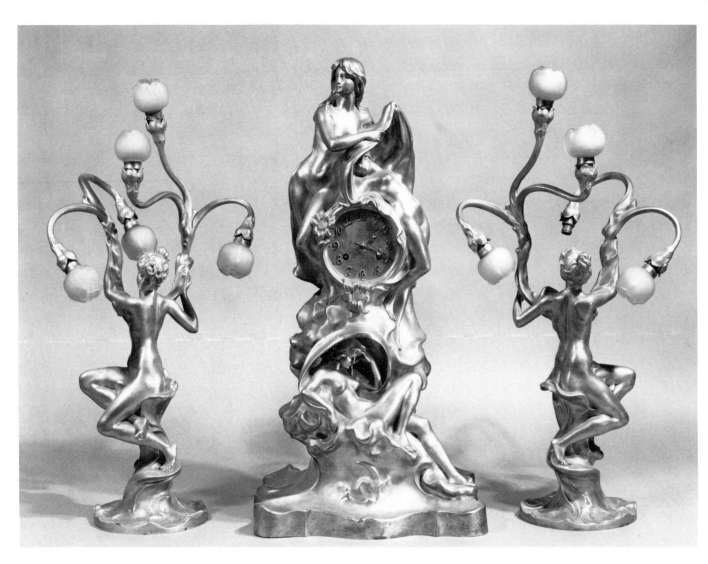

MAURICE DEBUT Mantel garniture comprising two candelabra and a clock in gilt-metal, for Tiffany & Co., New York.

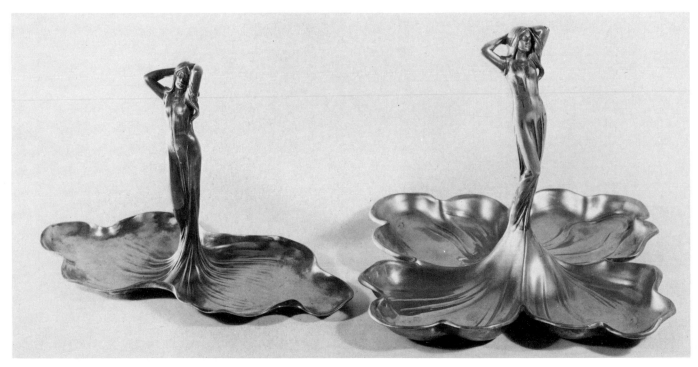

WURTTEMBERGISCHE METALLWARENFABRIK Two electroplated metal dishes. (Macklowe Gallery)

68

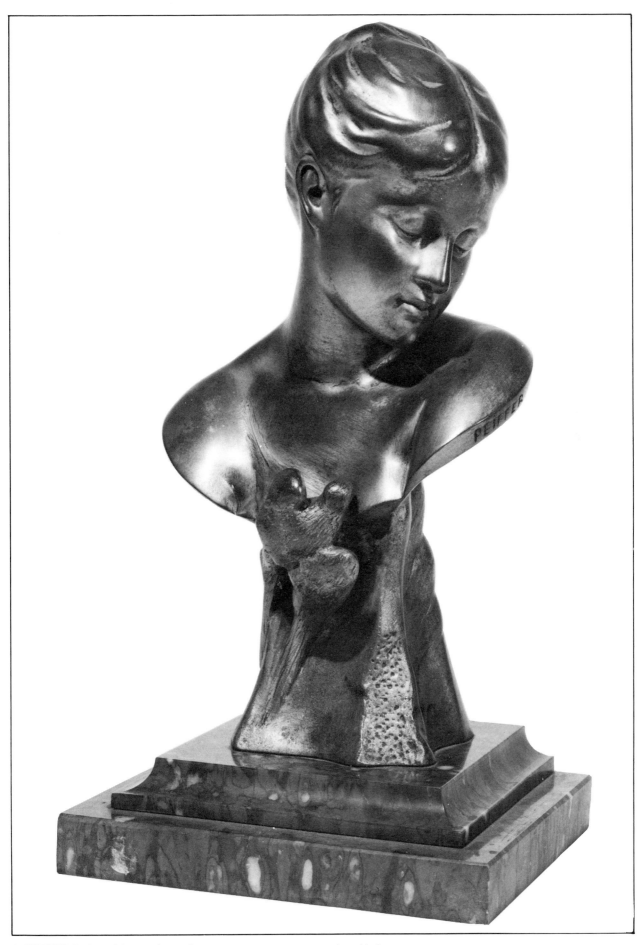

J. PEIFFER Patinated bronze bust of a young woman on a stepped marble base.

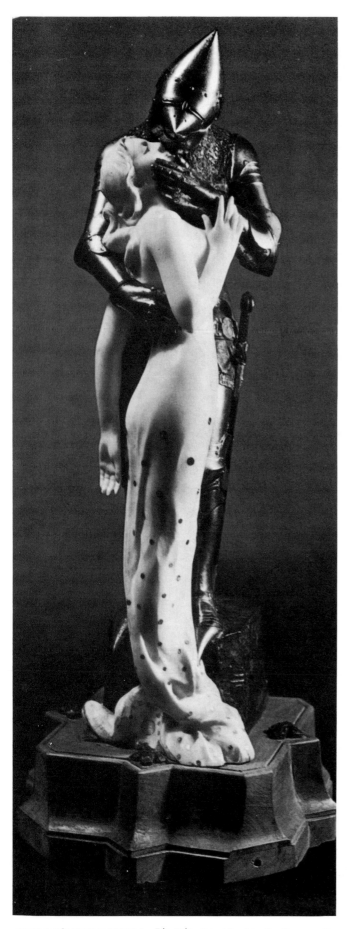

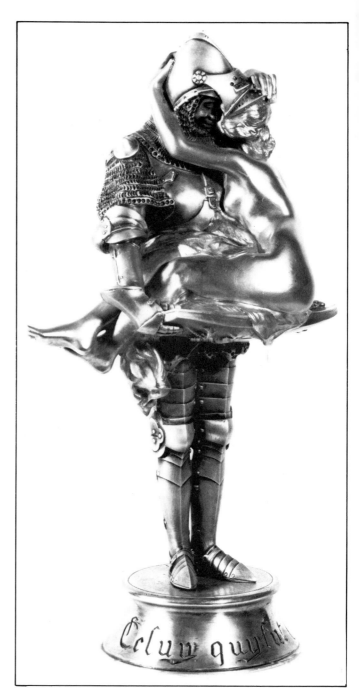

CLEMENCIN *Celui qui fut pris* (He who was taken) Gilt and silver-bronze statue of a knight in chain mail. (Galerie Tanagra)

JEAN-AUGUSTE DAMPT *La Fée Mélusine et le chevalier Raymondin.* The Knight Raymondin is made of steel, the Fairy Mélusine of carved ivory with gold and diamonds. (Scherer)

Opposite
E. WANTE *Source d'or* (Spring of Gold) Gilt and patinated bronze vase. (Macklowe Gallery)

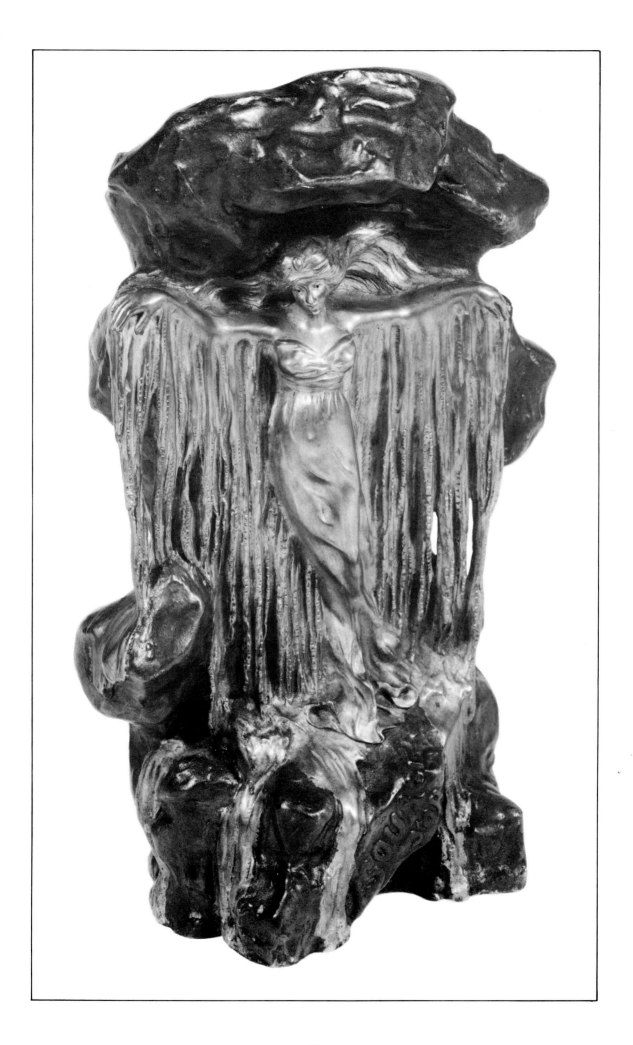

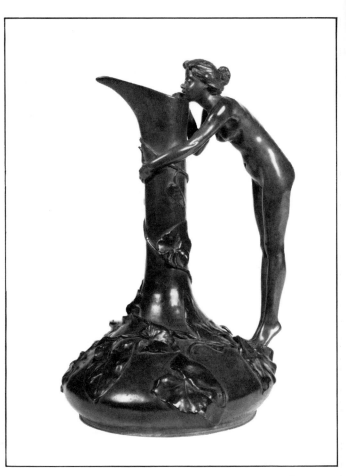

E. SIMONE Bronze bust of a blindfolded woman. (Macklowe Gallery)

JEANNE JOZON *Curiosité* Bronze pitcher exhibited at the Salon des Beaux-Arts.

Opposite
JEANNE JOZON *Nu à l'iris* Patinated bronze candlestick, exhibited at the Salon des Beaux-Arts.

Opposite
PHILIPPE WOLFERS *Fée au paon* (Peacock Fairy) Marble and bronze.
The peacock's tail contains *plique-à-jour* enamel eyes highlighted from
behind by electricity. (Mr. L. Wittamer-De Camps, Brussels)

PHILIPPE WOLFERS Bronze figure of a dancer. (Sotheby Parke Bernet)

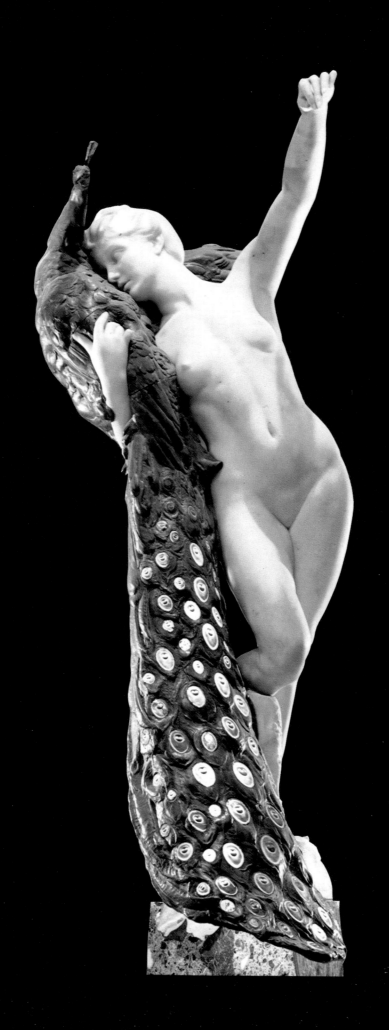

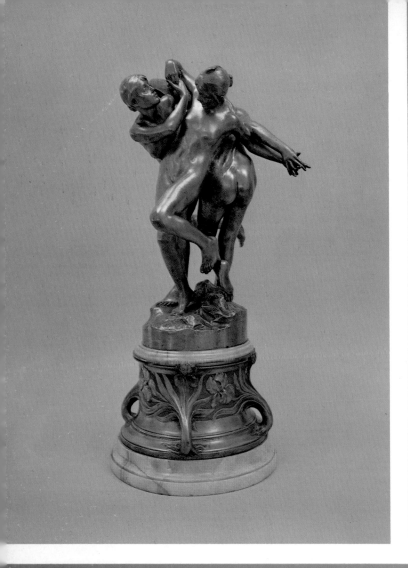

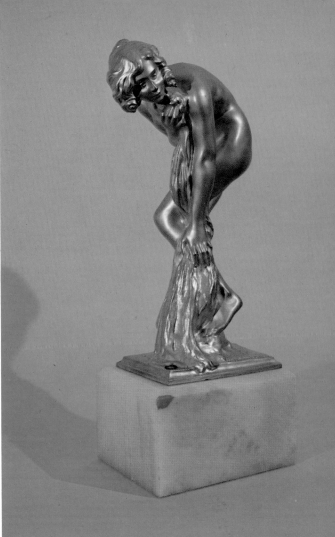

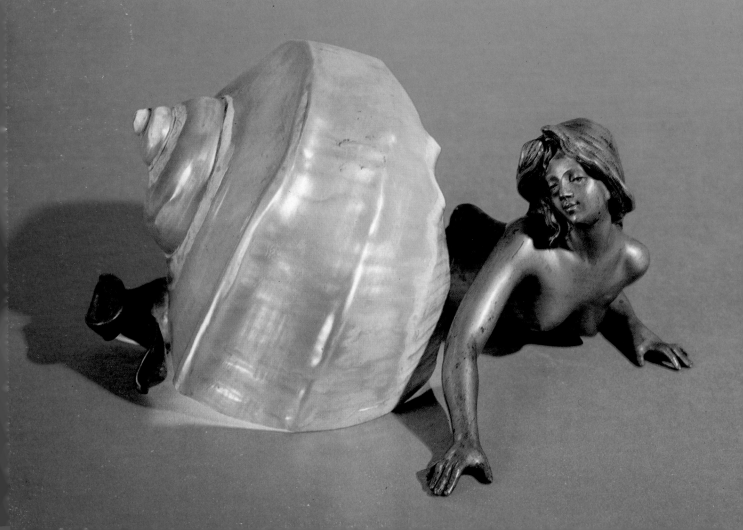

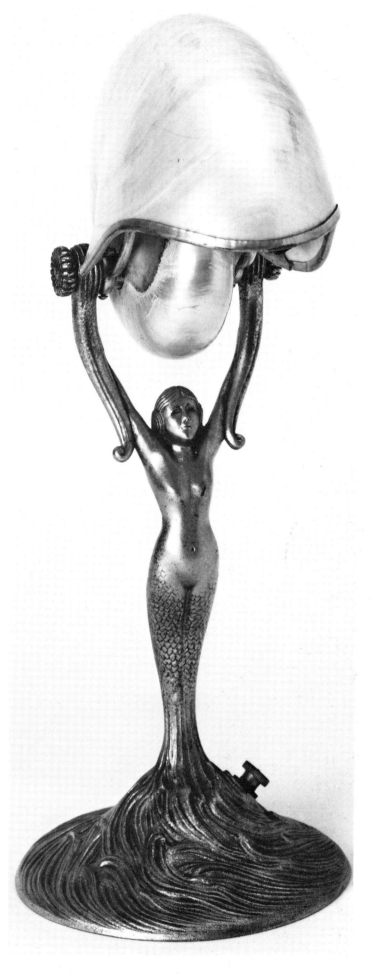

Opposite above left
EGIDE ROMBAUX *Venusberg* A gilt-bronze group of three maidens. (Mr. John Stern)

Opposite above right
LEO LAPORTE-BLAIRSY Gilt-bronze figure of a nude, with the sculptor's own foundry stamp. (Mr. John Stern)

Opposite below
THEODORE RIVIERE *Femme-escargot* (Snail—woman) Patinated bronze lamp with Marmoratus shell shade.

LOUIS COMFORT TIFFANY Chambered Nautilus table lamp on bronze mermaid base. Impressed 'Tiffany Studios, New York'. (Sotheby Parke Bernet)

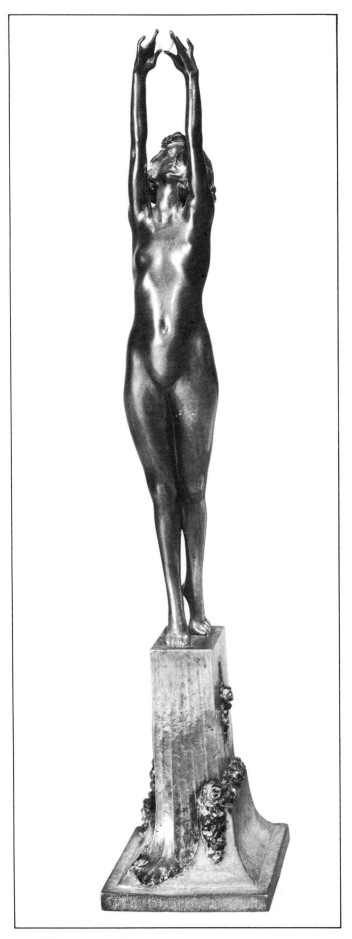

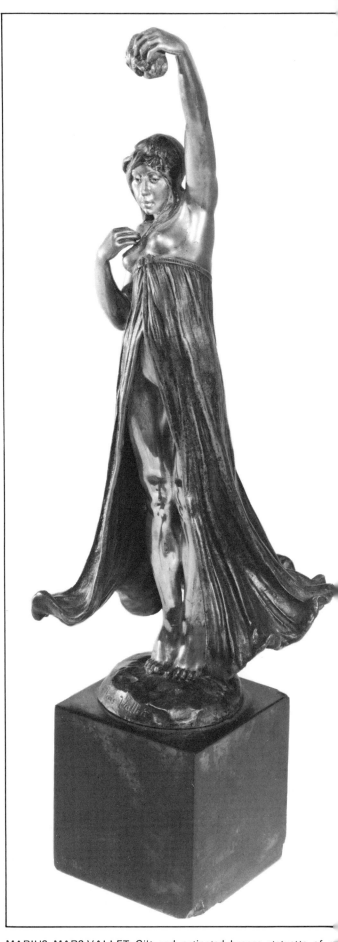

MAXIMILIAN LENZ *The Pearl* Patinated and silvered bronze with a pearl. (Victor Arwas collection)

MARIUS MARS-VALLET Gilt and patinated bronze statuette of a woman holding a mask in her raised hand. (Macklowe Gallery)

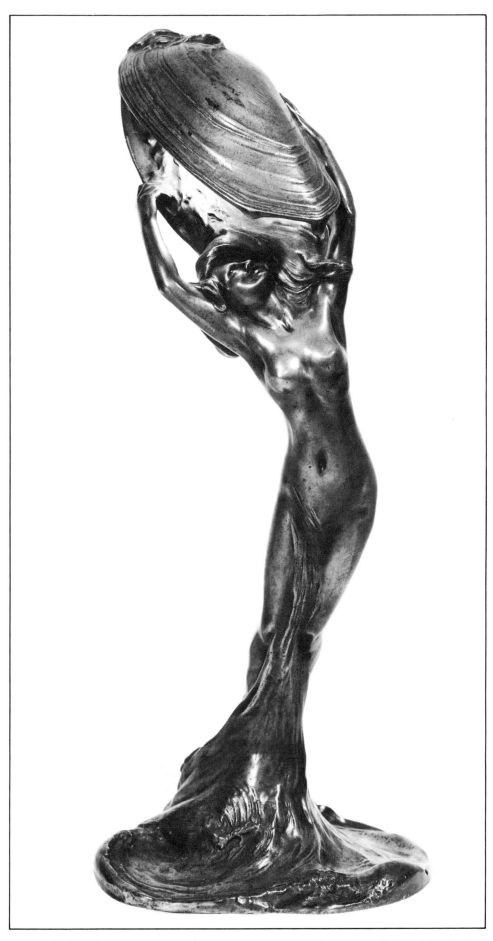

MAX BLONDAT *La Vague* (The Wave) Silver-patinated bronze figure, wired for electricity, the light bulb concealed within the shell.

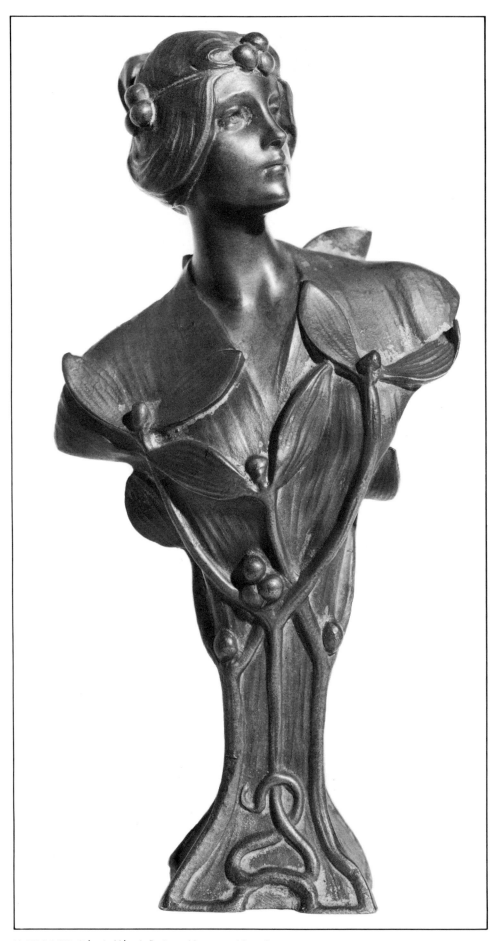

H. MULLER *Cléo de Mérode* Patinated bronze cabinet figure.

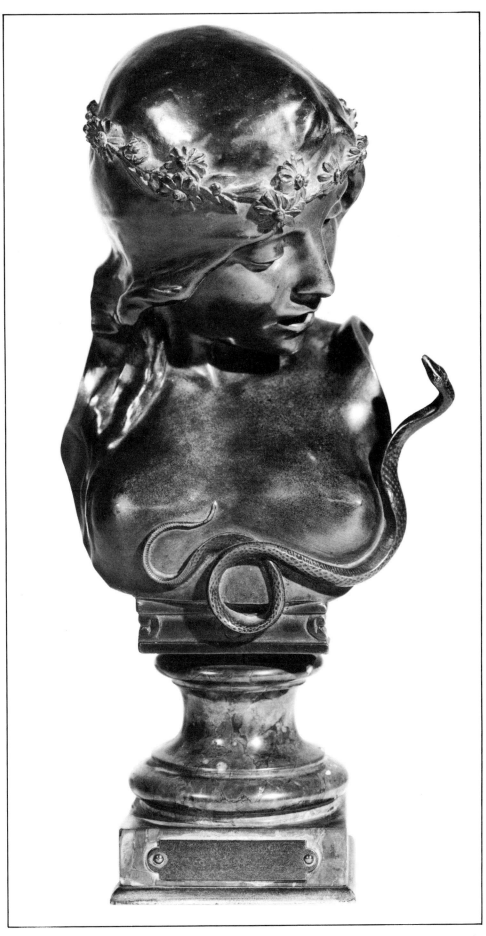

J. DE RUDDER *Cléopâtre* Patinated bronze figure on rouge marble base. (Victor Arwas collection)

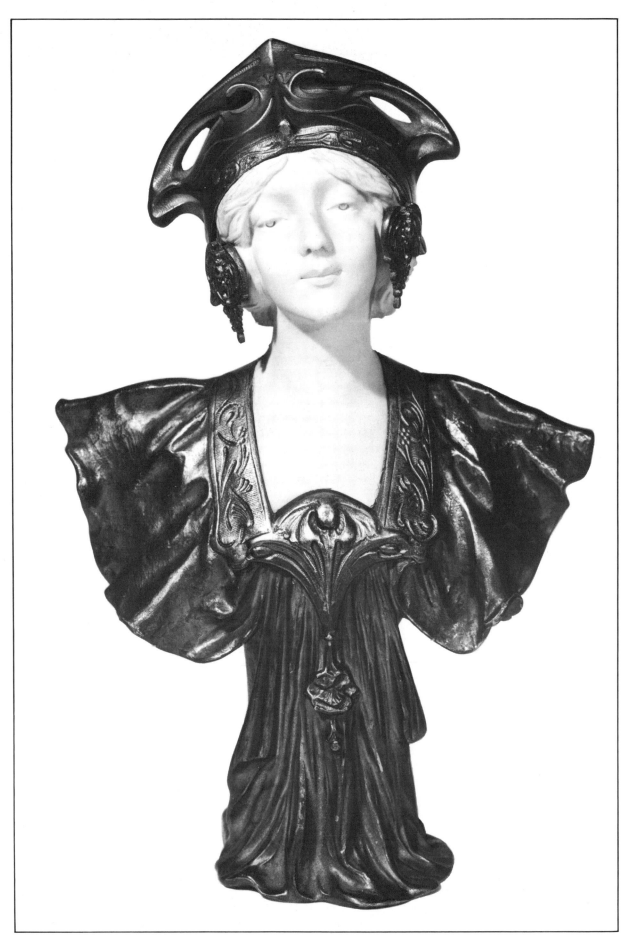

H. JACOBS Unglazed ceramic and patinated bronze figure.

Opposite
DELAGRANGE *La Liseuse* (The Reader) Glazed and unglazed
ceramic and gilt-bronze.

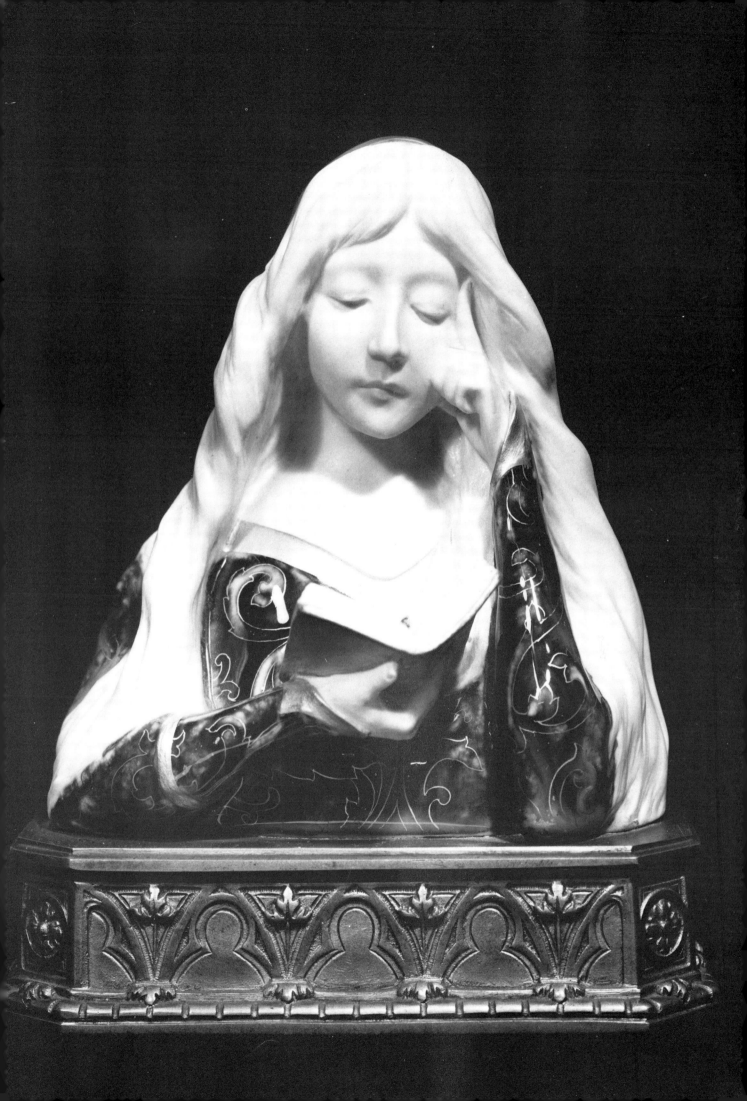

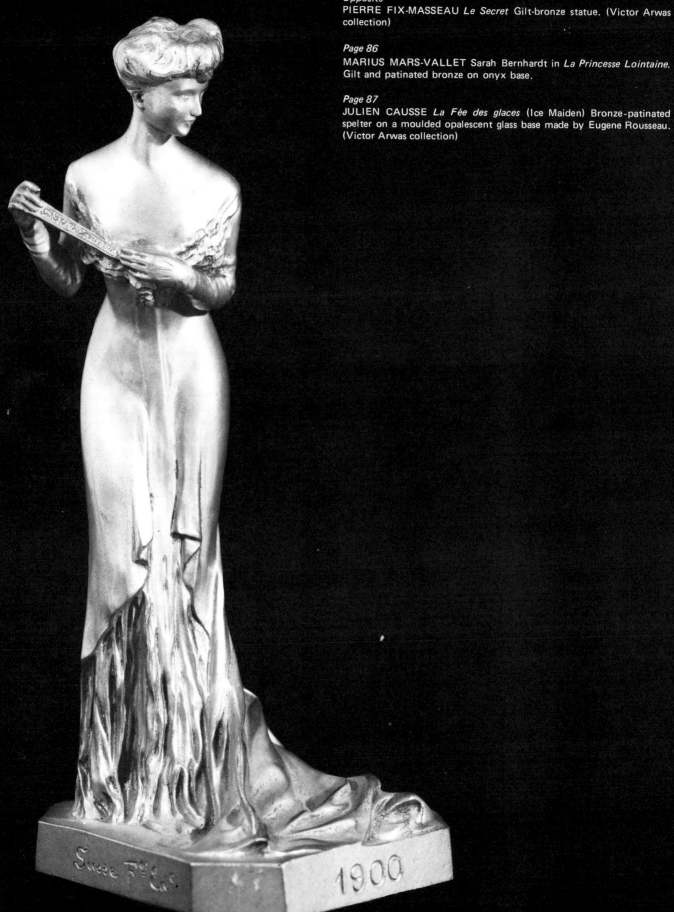

Opposite
PIERRE FIX-MASSEAU *Le Secret* Gilt-bronze statue. (Victor Arwas collection)

Page 86
MARIUS MARS-VALLET Sarah Bernhardt in *La Princesse Lointaine.* Gilt and patinated bronze on onyx base.

Page 87
JULIEN CAUSSE *La Fée des glaces* (Ice Maiden) Bronze-patinated spelter on a moulded opalescent glass base made by Eugene Rousseau. (Victor Arwas collection)

H. VARENNE *Elégante 1900* Gilt-bronze.

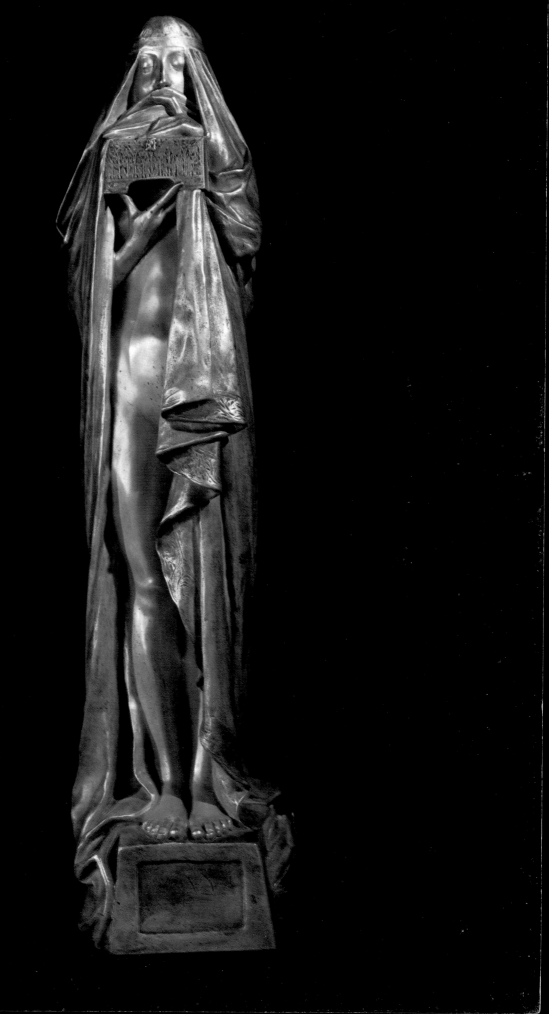

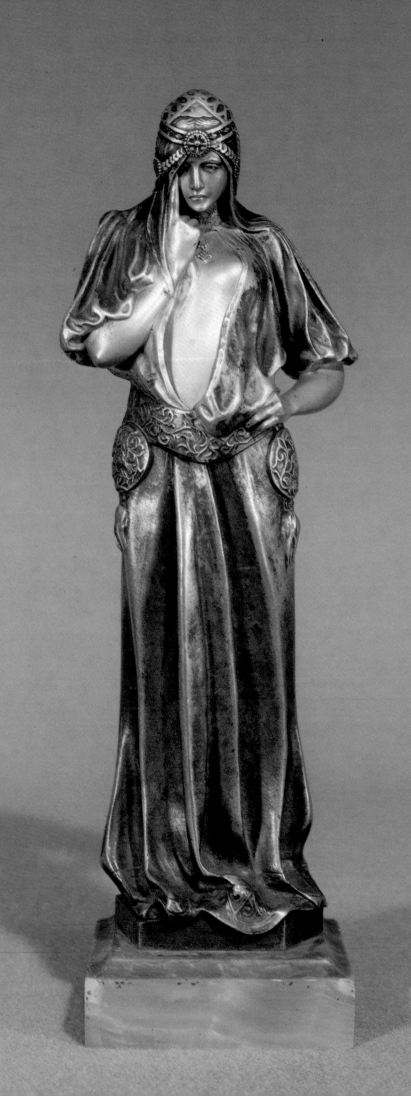

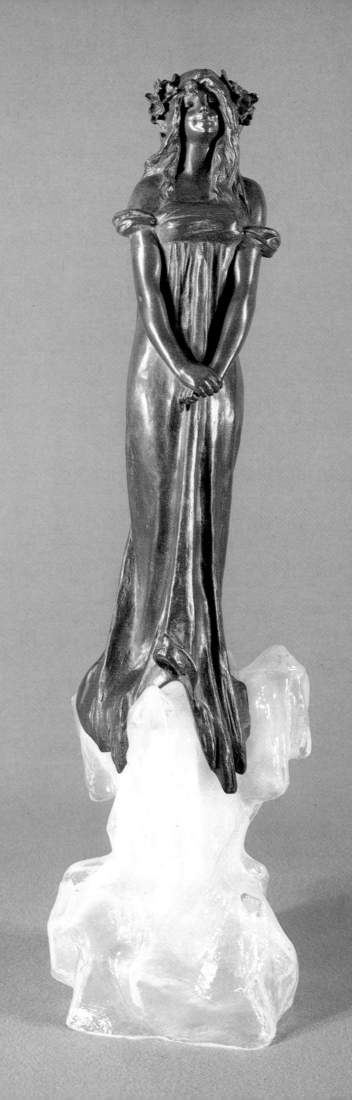

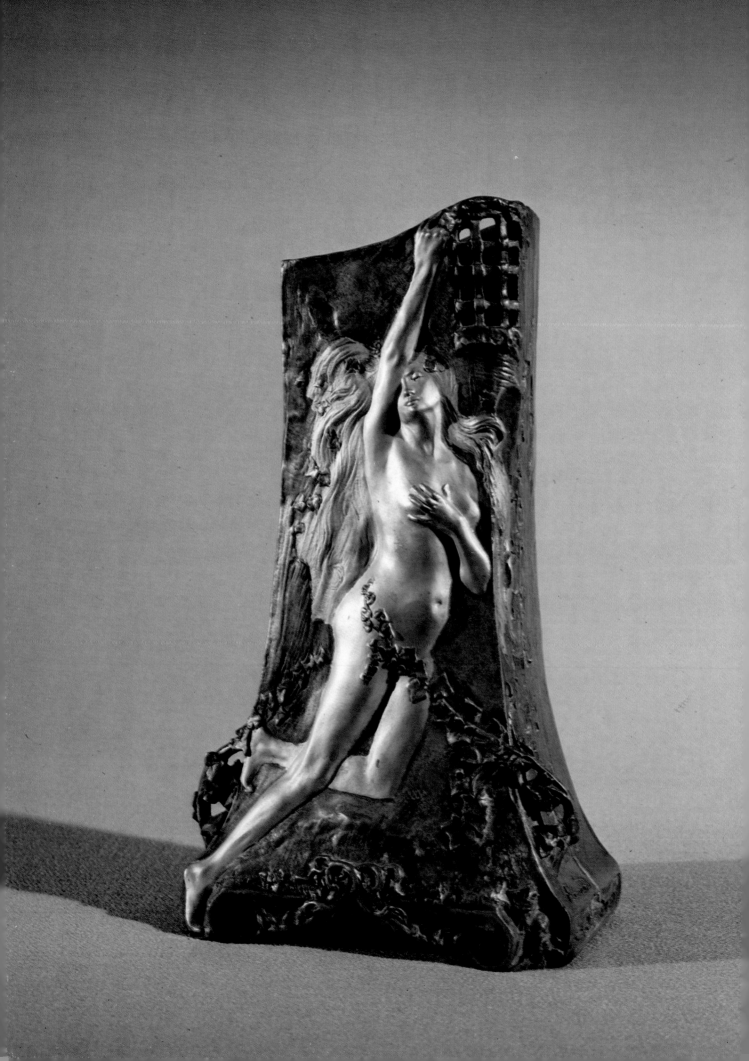

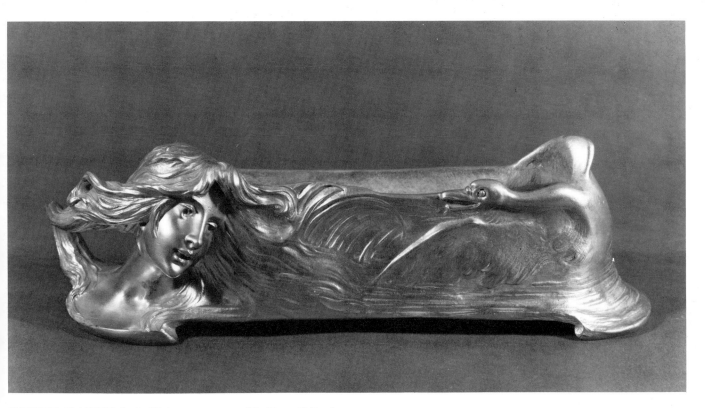

GEORGES FLAMAND *Leda* Gilt-bronze pentray. (Macklowe Gallery)

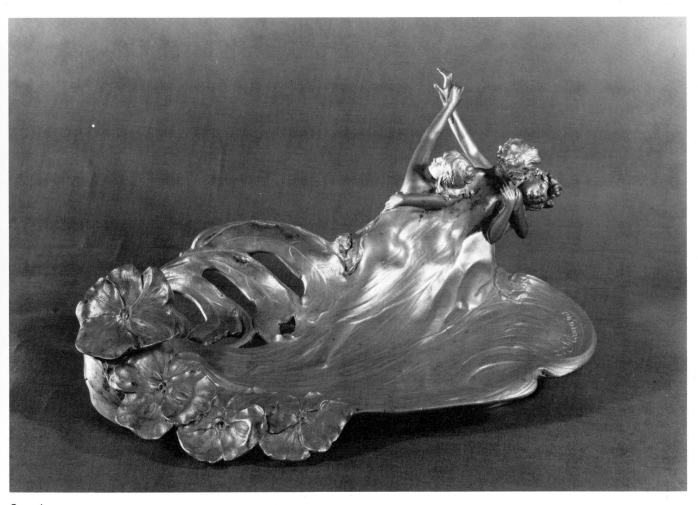

Opposite
GEORGES FLAMAND *La Fille dans le donjon* (Girl in the Dungeon)
Gilt and patinated bronze.

GEORGES FLAMAND Gilt-bronze inkwell and pentray combination,
incorporating three naiads. (Macklowe Gallery)

89

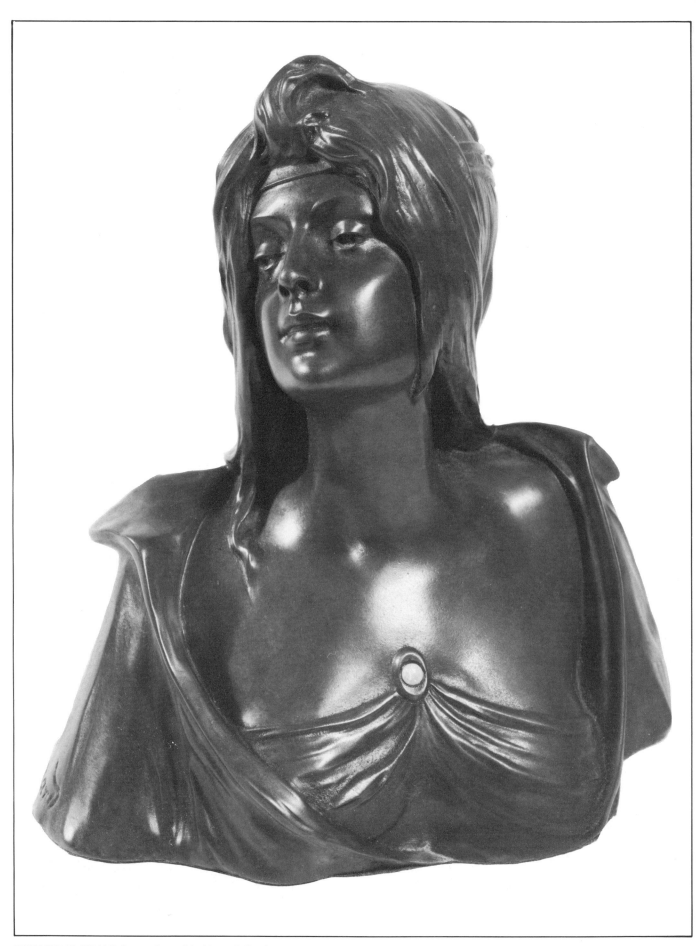

GEORGES FLAMAND Bronze bust. (Macklowe Gallery)

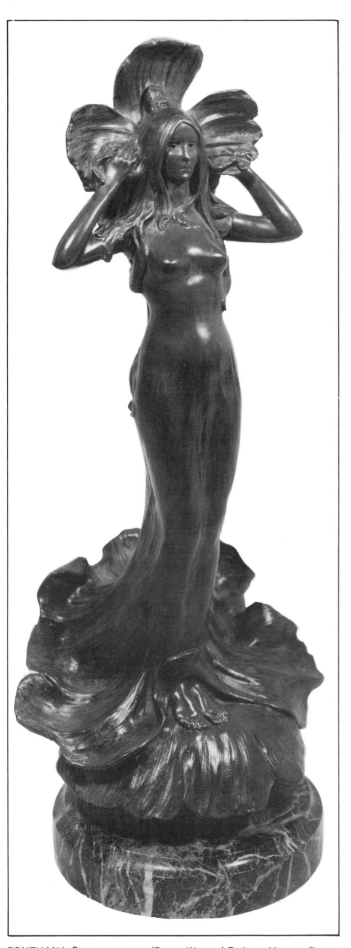

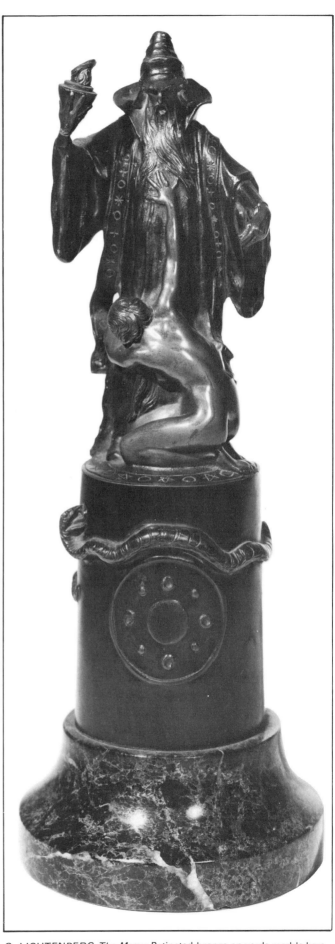

FONTHANA *Femme au pavot* (Poppy Woman) Patinated bronze figure of a woman, her head framed by three poppy petals, the base of veined marble. The bronze is stamped 'Bronze Garanti au titre: L.V. Deposee'. (Macklowe Gallery)

G. LICHTENBERG *The Magus* Patinated bronze on verde marble base.

EMMANUEL VILLANIS *L'Otage* (The Hostage) Patinated bronze figure.

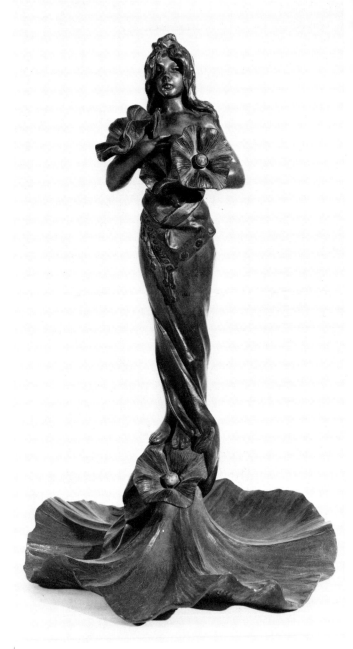

EMMANUEL VILLANIS *Les Nénuphars* (Nymph with Lilypads) Patinated bronze figure.

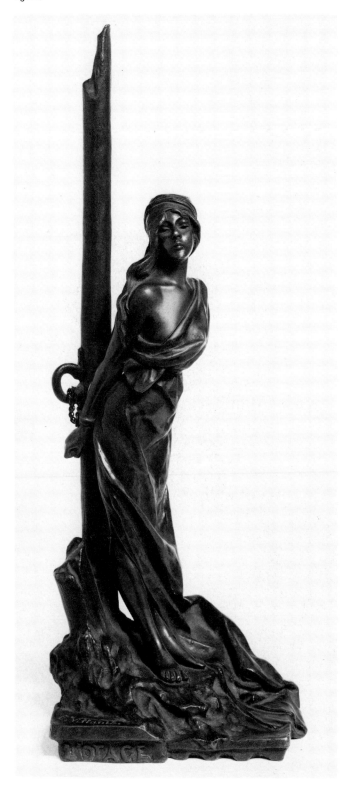

Opposite
EMMANUEL VILLANIS *Capture* Bronze figure.

92

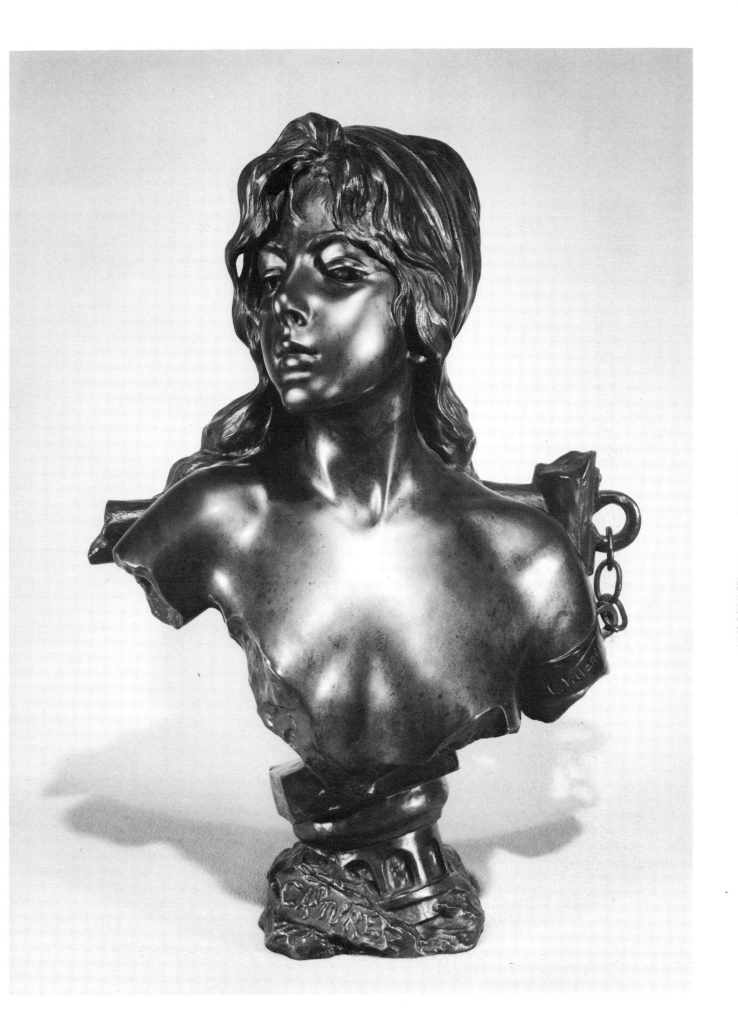

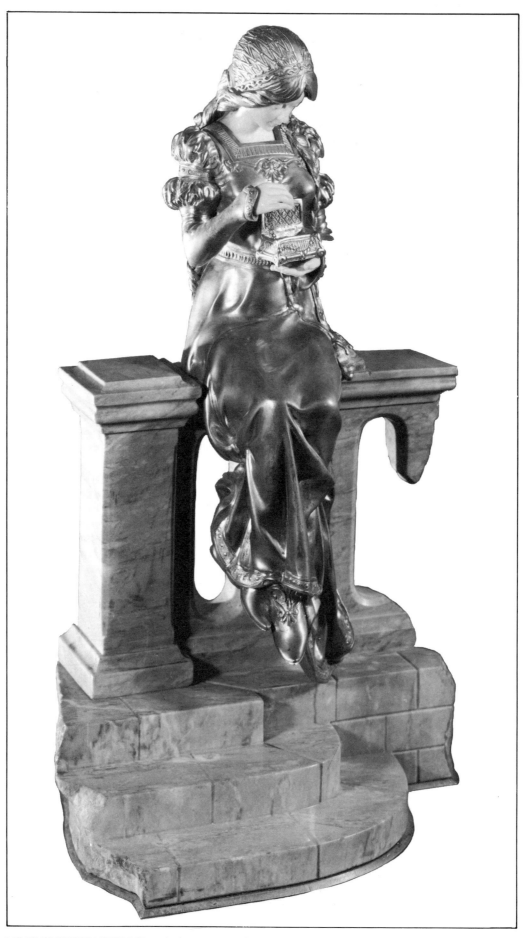

LOUIS-ERNEST BARRIAS Chryselephantine statue (ivory and bronze) of a woman sitting on a marble balustrade examining the contents of a small casket. (Macklowe Gallery)

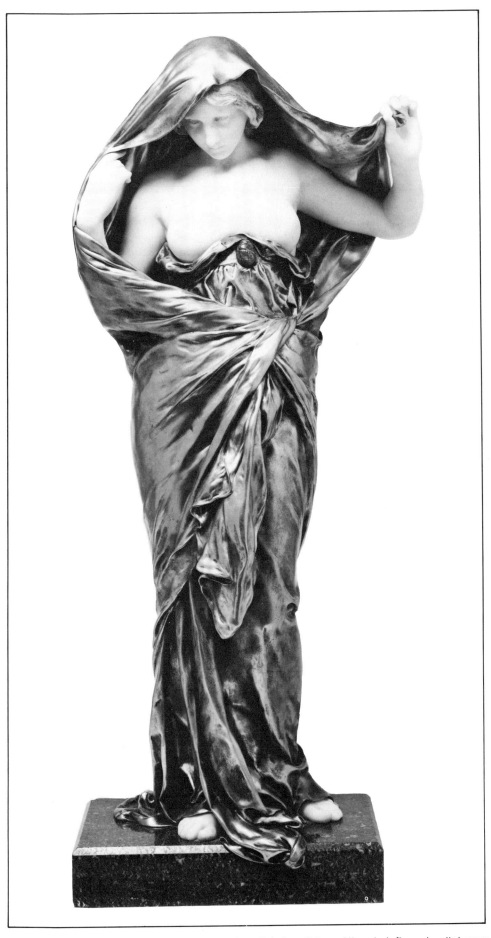

LOUIS-ERNEST BARRIAS *Nature unveiling herself before Science* Allegorical figure in gilt-bronze and marble. (Sotheby Parke Bernet)